THE ELEVENTH HERE'S HOW

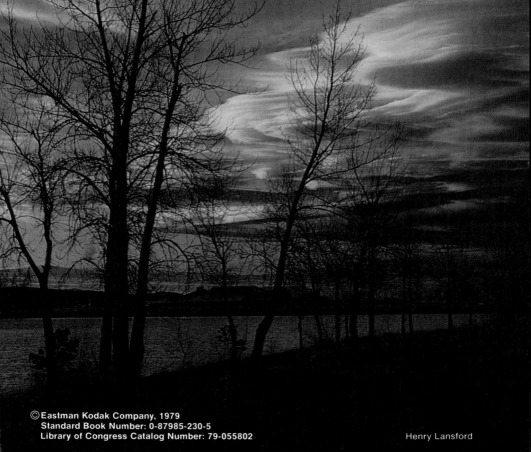

©Eastman Kodak Company, 1979
Standard Book Number: 0-87985-230-5
Library of Congress Catalog Number: 79-055802

Henry Lansford

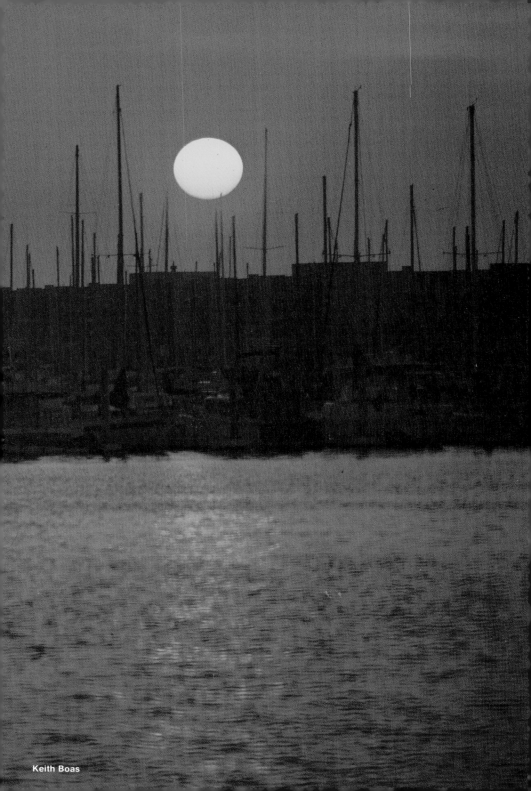

Keith Boas

CONTENTS

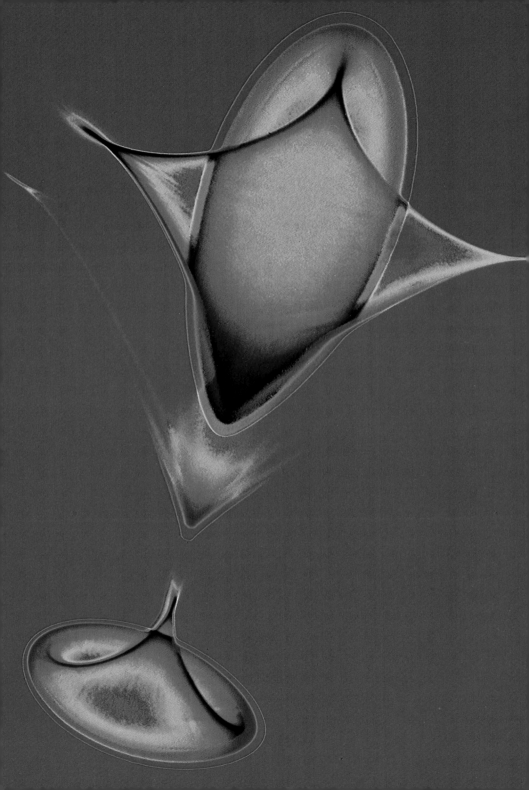

Imagineering—the Key to Creative, Contemporary Photography

by Martin A. Folb

Martin Folb is a research physicist whose investigations have covered such diverse subjects as particles that may travel faster than the speed of light and new high-power lasers and laser communication systems. Currently he heads his own company—Duotronic Systems—devoted to the manufacture of dissolve-control units and programmers, electro-optical and scientific apparatus, and laser home-entertainment systems.

Martin's interest in photography began while he was an undergraduate majoring in physics at Cal-Tech. Since 1974, he has actively participated in photographic competitions around the world. He has accumulated more than 250 medals and 1300 acceptances in such varied fields as stereo, color, nature, and photojournalism. His many awards include four Sydney (Australia) Silver Trophies and five Charles A. Kinsley Memorial Trophies awarded by Eastman Kodak Company at the Annual Photographic Society of America (PSA) Exhibition. In 1978 he was rated by PSA as the number one stereo exhibitor in the world.

Martin presents many lectures and seminars on creative photography and corresponds with people throughout the world on techniques he has developed. In addition, he is an ardent science-fiction enthusiast, as you'll see demonstrated in this article and his slides and their titles.

WHAT IS IMAGINEERING?

Contemporary photography, as defined by the Photographic Society of America, is a departure from a realistic representation. This contemporary quality can be realized through any of a variety of different techniques: the Sabattier effect, multiple exposures and special filtration, posterization, etc. These techniques are only the ENGINEERING tools used to create the final, exciting image. Certainly the most important component of the ultimate picture is the photographer's IMAGINATION. By combining these two critically important elements into one idea, we obtain IMAGINEERING—the interplay between a person's technical photographic skills and the unbounded use of imagination. It is this interplay that will be stressed throughout this article—how to explore new vistas in photography and create for yourselves a world as thrilling as any scene from the movie *Star Wars* or the television series *Star Trek*.

LENS ABERRATIONS—WHAT THEY ARE AND HOW THEY ARE CREATED

The image shown in the accompanying illustration is not an alien creature left over from the casting department of *Star Wars!* Rather, it is an aberration photograph. In this process you can turn bothersome lens aberrations into breathtakingly ethereal pictures. Some of you are no doubt thinking that lens aberrations are supposed to be avoided, and that is why you spent two weeks' salary for a good lens. Generally, these lens defects *should* be avoided, since they rob the image of

sharpness, color saturation, and contrast. How then, can we use them to our advantage? The answer is to be found in a brief discussion of aberrations and a description of some of the more common kinds.

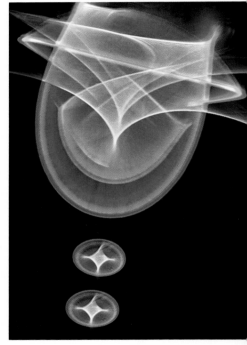

Tholian Starship—An aberration of light in its most exciting form! This image is an excellent example of both coma and chromatic aberration.

Whenever light strikes a piece of glass, some strange things can happen. The white light we see can be broken up into its spectral colors, or the entire beam of light can be unduly bent or distorted. It's this distortion or *aberration* of the image that we will examine. Most modern camera lenses are relatively free of these distortions or aberrations. This is primarily possible because high-speed computers are used in the design of the lenses. The lenses we will be discussing are the simple, inexpensive kinds (such as magnifying lenses of one-element design or plastic lenses). One of the most common forms of lens faults is chromatic aberration. In this instance, all of the different colors in white light are brought to focus at different points along the optical axis of the lens. This is because the bending power of the glass that makes up the lens (technically referred to as the index of refraction) varies with the color of light. The colors near the blue or violet end of the spectrum, which are bent more strongly, focus closer to the lens. The colors near the red end of the spectrum are refracted to a lesser degree and are imaged farther away from the lens. A lens of only one element (and therefore one type of glass) will *always* have chromatic aberration. In order to correct this problem, better lenses are made of at least two elements, one positive and one negative, each from a different type of glass. In this way, the lens can focus almost all colors to the same point.

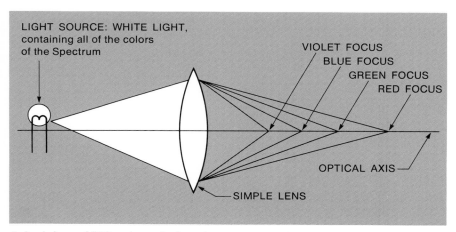

A simple lens exhibiting *chromatic aberration*: a phenomenon in which different colors come to focus at different points along the optical axis of the lens.

One other aberration known as *coma* will play an important part in the creation of these fascinating photographs. Basically, all light rays striking the lens from a direction off the optical axis of the lens will be imaged at slightly different magnifications. Instead of parallel light rays forming a single spot (as a high-quality lens will do), a series of different-size spots will be formed. The image, which tends to look like a small comet, hence is known as coma.

Three other aberrations that will be encountered with most simple lenses are pincushion and barrel distortions and Schlieren (or glass run). Barrel and pincushion distortions are named because of their resemblance to those objects. Schlieren is a phenomenon in lenses caused by variations in the density of the glass. To get an idea of the effect produced, look through the bottom of an inexpensive glass tumbler. The wavy images seen are caused by this variation in density. Most lenses that are cast, rather than ground, do not have uniform density.

So much for the theory of how aberrations are formed and analyzed. Let's turn our attention now to how to use them for photographs that are "out of this world."

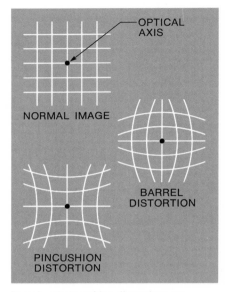

Barrel and pincushion distortions are two more aberrations encountered with simple lenses.

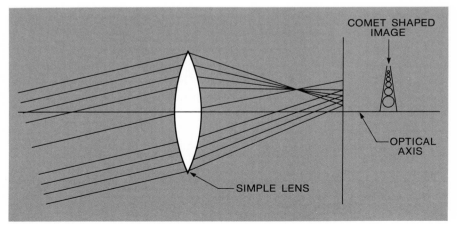

Coma **is an aberration that causes a point object just off the optical axis of the lens to be imaged looking like a small comet.**

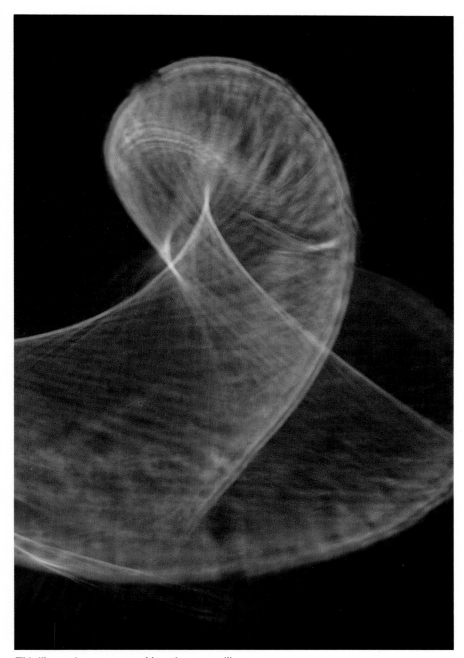

This illustration was created by using an auxiliary
lens that had Schlieren—a variation in density
of the glass.

CLOSE ENCOUNTERS WITH A LITTLE LIGHT AND WATER

The photography of aberration figures is relatively simple and requires little more than patience. The following basic equipment will be needed:

Camera. A single-lens reflex (SLR) camera that features through-the-lens metering is a must, as the figures are constantly changing. Exposures can vary from 1/30 to 1/2000 of a second. A sturdy tripod and a cable release are also required for this work.

Camera lenses. Almost any lens with a focal length between 85 and 200 mm can be used. I find a 135 mm lens to be the most useful. The lens can be mounted on either extension rings or a bellows. The bellows is the most practical, as it allows for the magnification to be changed easily. The aberrations change both shape and size with variations in magnification.

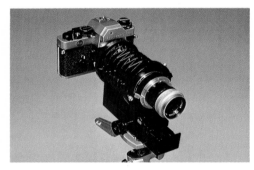

Typical camera setups for aberration photography showing a single-lens reflex camera attached to a bellows and to an extension-ring set. A 135 mm lens is shown on the camera in each setup.

Clear glass disc and bowl. Small droplets of water formed by condensation on the underside of a clear piece of glass provide a source for aberrations. The glass is used to cover a bowl filled to within an inch of the top with hot water. The bowl should be a dark color (blue or black) so that the patterns will stand out against the background. A clear bowl can be used also, as long as it is placed on top of a dark-colored cloth or paper.

Supplementary lenses. The water droplets that form act as poor-quality lenses, teeming with aberrations. However, in order to add more aberrations to the system, we attach 10 to 30 diopters of supplementary lenses to the camera lens. Used individually, these supplementary lenses can be quite excellent. But by combining several into a high-power unit, we cause the aberrations to multiply. This is exactly what we want! This is the one field in photography in which the worse the optical system is, the better the results are likely to be. Any supplementary lenses can be used. Generally, I find a total power of 20 to 25 diopters to be most useful. Many camera stores sell accessory lenses in the 1 to 10 diopter range in sizes to fit any lens. Some stores even have used lenses at a reasonable price.

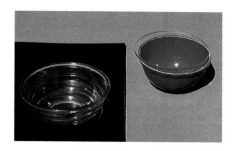

A dark bowl or a transparent one sitting on a dark material covered with a clear-glass plate is one of the main pieces of equipment used in aberration photography.

Getting the Act Together

Once the necessary materials have been gathered, you can start exploring the unknown. To begin, place the bowl containing the hot water onto a sturdy table or other support and level as much as possible. Otherwise, the water droplets that form might move to the side. I like to work

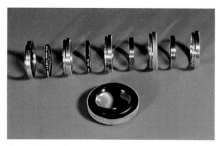

Several supplementary lenses can be combined to produce the desired power or diopter rating and held together with a rubber band or tape.

outdoors, utilizing the sun as the source of light. For this, the day must be bright and clear. You need a strong, nondiffused source of light to create the patterns. Generally, it's best to work with morning or afternoon lighting to minimize the possibility of reflections from the glass disc that can occur when the sun is directly overhead.

Leave the bowl undisturbed for about 30 minutes. Many droplets will form on the glass disc. You will notice that some sparkle brilliantly. These are the droplets that are likely to form some of the most interesting patterns. Each water drop acting as a simple lens contains many of the aberrations we have discussed. Since no two drops form in exactly the same manner, the aberration patterns they produce will always be slightly different. This is what makes the pursuit of the perfect image so fascinating!

To photograph the patterns, simply aim the camera in the direction of the sparkles. It will be necessary to experiment with the distance from the camera lens to the glass disc. This will vary because of differences in the supplementary lenses and the focal length of the camera lens. Often you'll find interesting patterns when this distance is between 1 and 4 inches. It's important to set the camera lens to its *maximum aperture* (wide open), as stopping it down will cause many of the off-axis aberrations to disappear. If your camera has through-the-lens metering, try to take your exposure reading from the brighter sections of the patterns. A good idea is to bracket the exposure, as one exposure may be far more pleasing than another. I prefer to use a slower film such as KODACHROME 25 or KODACHROME 64 Film. Even with relatively slow emulsions, since you are shooting wide open, you may find that your camera does not have a shutter speed fast enough to handle such bright subjects. In that case, neutral density (ND) filters can be attached to the front of the supplementary lens. A 0.60 ND filter that reduces the light level to 1/4 of what it was (sometimes called a 4X) should be satisfactory for even the brightest patterns.

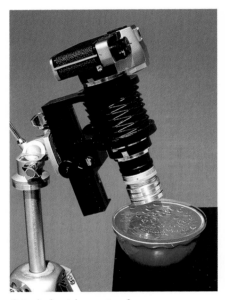

A typical outdoor setup for photographing the aberations produced by droplets of water or viscous liquids.

When you observe an interesting pattern, photograph it at once. If you hesitate, the water drop and your chances for a possible prizewinning photograph may become just a fond memory. Be sure to change the magnification of the system while viewing a pattern. Variations in structure of the pattern can be incredible. The glass disc may eventually become covered with a general fog. At this point, remove the disc and dry it. Then place it back on the bowl so that new droplets will form. It might be necessary to reheat the water if it has cooled considerably.

VARIATIONS ON A THEME

Once you become familiar with the techniques for photographing intriguing moisture patterns, you can experiment with several materials other than water. For instance, corn syrup, glycerin, oil, or any other viscous liquid. Put these liquids onto the clear-glass disc one drop at a time, and then turn the disc over and place it on the bowl (the drops will then hang downward). A large toothpick works well in transferring such liquids to the disc. When viscous liquids are used, no water is necessary in the bowl. The bowl serves only as a support and colored background for the disc with the several drops of syrup or oil on it.

Another element that can be varied is the supplementary lens you use. You do not have to limit yourself to standard photographic close-up lenses. You can try any short-focal-length lens. Many will yield extraordinary aberrations. Lenses with focal lengths between 35 and 100 mm are generally best. Sources for these lenses include hobby shops and surplus stores, as well as Edmund Scientific Company, 702 Edscorp Building, Barrington, New Jersey 08007. Condenser lenses, such as those used in slide projectors and enlargers, make excellent aberrators. Because of the unusual shapes and sizes of such lenses, they will probably have to be attached to the camera lens with a masking or transparent tape.

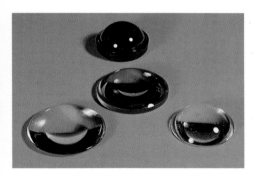

Some other lenses that can be used to create fascinating aberration patterns.

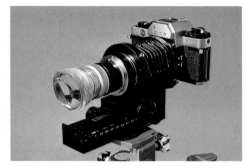

Most projector and enlarger lenses will have to be taped to the camera lens.

PHOTOGRAPHING ABERRATIONS INDOORS

Although the Chamber of Commerce may not agree with me, the weather in California is not always clear and sunny. For that reason, I sometimes move my aberration equipment indoors. Most of the operating procedures remain the same, with the exception of utilizing an artificial light source, such as a small slide projector. It is important to insert a 2 x 2-inch piece of cardboard into the projector with a 1/8 to 1/4-inch hole punched in the center. This hole acts as a point source, approximating the sun in the outdoor situation. Without it, the broad patterns generated would lack fine detail.

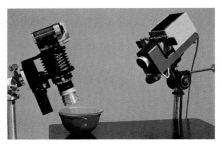

An indoor setup for photographing aberrations. The source of light can be a small slide projector.

Because a slide projector can hardly be as bright a source as the sun (especially with the punched cardboard in place), indoor exposures will generally be quite a bit longer. Exposure times of 1/4 second to 1/125 second are not unusual. A tungsten film, such as KODAK EKTACHROME 50 Professional Film (Tungsten) or KODAK EKTACHROME 160 Film (Tungsten), should be used with the tungsten light source. Daylight films will yield warmer results with poor blues. These longer exposure times dictate an *absolutely rigid* support for the camera and the bowl, as any movement will be greatly magnified by the optical system. Use of a cable release or a remote-control system is imperative.

Whether indoors or outdoors, the myriad patterns produced by these procedures boggles the mind. It is, perhaps, the ultimate photographic "trip"—the essence of IMAGINEERING. Some of the patterns that I have been fortunate enough to capture on film, utilizing the techniques just described, are illustrated on the following pages.

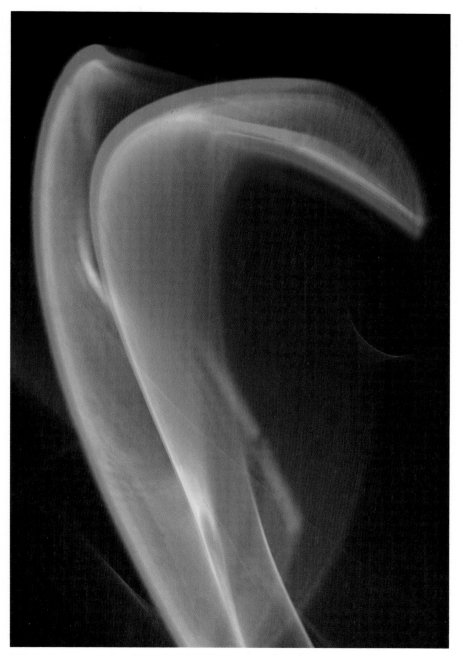

This pattern was produced by using the yellow aspheric lens shown on page 13.

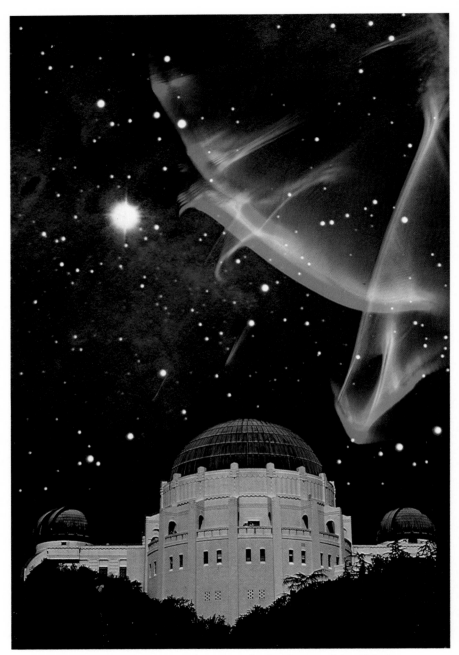

In Search of the Ancient Astronomers is an example of a photograph in which the aberration was combined with *real-world* images. There are three exposures on this one slide: one for the star field, one for the planetarium, and the final one for the aberration. In one salon, this slide was awarded two gold medals and a silver trophy!

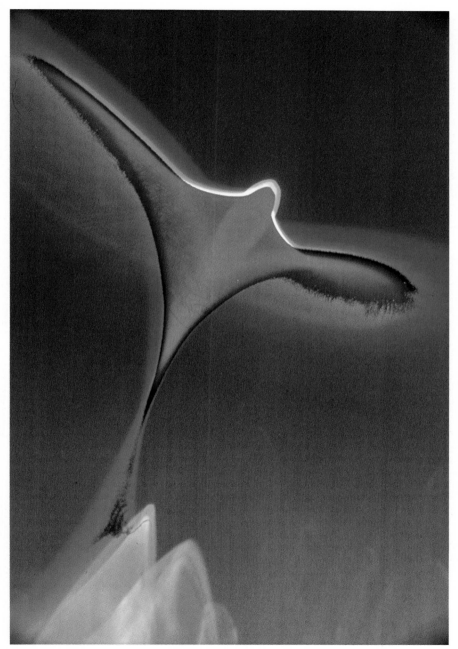

Diaphanous Apparition has been one of my most successful slides. It has received more than 40 gold medals.

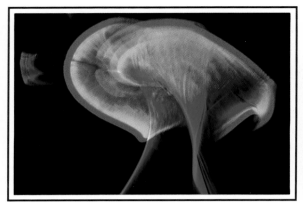

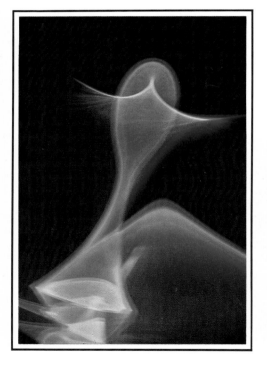

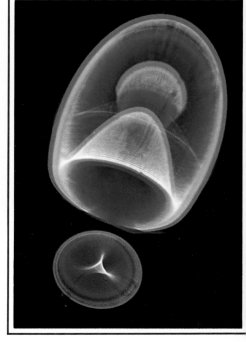

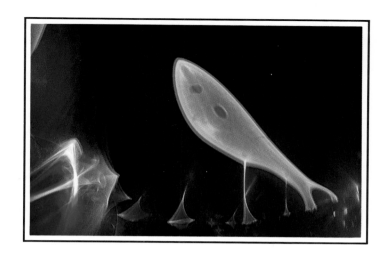

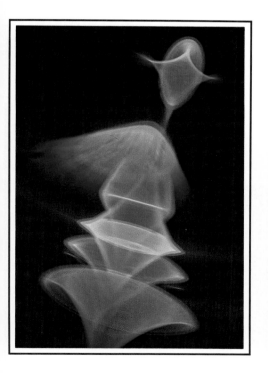

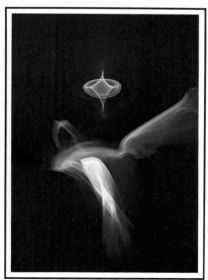

21ST CENTURY PHOTOGRAPHY USING THE LIGHT FANTASTIC— THE LASER

On *Star Trek,* whenever things got dull, Captain Kirk or the cerebral Mr. Spock would issue an order to go from sublight speed into *warp drive.* It conjured fantastic images of galactic pursuit at speeds far greater than that of light. Through photography and the laser—one of the most amazing discoveries of the century, we can now join (at least in spirit) those interstellar adventurers!

Laser is an abbreviation for **L**ight **A**mplification by **S**timulated **E**mission of **R**adiation. It is a very special source of light (somewhat like a high-class light bulb). Lasers produce light which is almost perfectly monochromatic— meaning that the light that comes from such a device is only one pure color. The second important characteristic of laser light is its coherence. Coherence is a term which means that all the light waves are in step, each moving in exact unison with surrounding waves. In contrast, a regular light bulb produces white light that contains all the colors of the spectrum. These many-color wavelengths, completely out of step with each other, are incoherent.

A small helium-neon laser that produces 1/2 to 1 milliwatt (1/2000 to 1/1000 W) of brilliant red light can be used to produce some dramatic effects. Suitable units are available from a number of sources (cost—about $200), such as Edmund Scientific Company (page 13); Coherent Radiation, 3210 Porter Drive, Palo Alto, California 94304; and Spectra-Physics, 1250 West Middlefield Road, Mountain View, California 94042. If you happen to live near a university or well-equipped high school, it might be possible to borrow or use a laser belonging to the physics or science department. There are lasers that produce colors other than red; however, they are very complex and costly instruments.

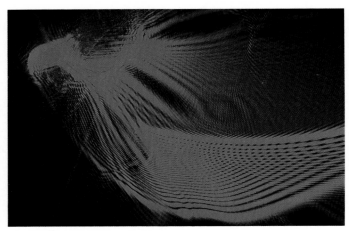

One of the fascinating patterns that can be produced with a small helium-neon (He-Ne) laser.

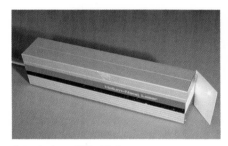

A typical small He-Ne laser that produces between 1/2 and 1 milliwatt of output.

Setting Up the Laser Spectacular

When you use the sun or tungsten light, water droplets produce the aberrations. With the laser you will use glue to create the patterns. A small clear-plastic disc or plate is covered with a *thick* coating of model-airplane cement. Any size or shape of disc will do—1/8-inch Lucite or Plexiglas material is excellent and is available from plastic-supply stores. As the glue dries, tremendous strains are set up in the mixture. These strains act much like Schlieren (or glass run), a phenomenon discussed on page 8. As the laser light passes through the material, the beam will be refracted or bent in many different directions. Since the laser light waves are all in step initially, they will produce complex and beautiful interference patterns after leaving the disc.

In a typical setup, the light from the laser passes through the coating of glue on the disc. The pattern created is projected onto a piece of white cardboard. Moving the cardboard away from the disc makes the image larger, and moving it closer makes it smaller. (This is exactly the same effect as when you project slides, except in this case you don't need a lens.) The disc can be held with clothespins, clamps, large office clips, etc. The most important thing is that the disc be held *firmly*. To change the pattern, simply move the disc so that the laser beam strikes it in a different place. The variety of patterns produced will amaze you.

A small clear-plastic disc, coated with model airplane cement, is used along with the laser to create intricate and fascinating patterns.

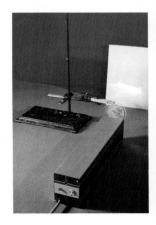

Here are all the elements needed to produce laser designs. The patterns will be projected on the white card as shown in the illustration.

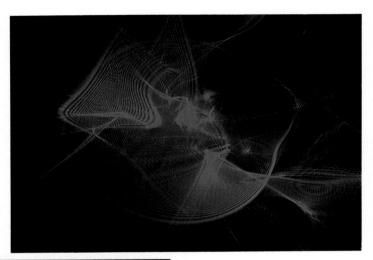

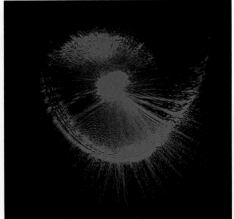

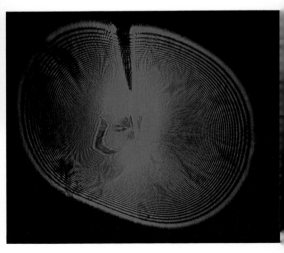

Patterns produced by the laser and a glue-coated disc. Eat your heart out R2D2!

Photographing Laser Patterns

Laser patterns are photographed directly from the cardboard. Since the light intensity is low, it will be necessary to work in a dark room. Some lasers emit light from their gas discharge tube along with the red laser output. This extra light can wash out the pattern. If this happens, simply punch a hole about 1/8 inch in diameter (or slightly larger than the diameter of the laser beam) in a piece of cardboard. Then tape the cardboard over the output end of the laser, allowing only the red beam to come through and blocking off all other distracting radiation.

Place the camera onto a tripod and focus it on the pattern you wish to photograph. The tripod can be placed to the right, left, or behind the laser. It makes little difference, as long as you have an unobstructed view of the pattern. Either Daylight or Tungsten film can be used, since the laser produces only one color. The chances are that your through-the-lens meter will not even give a reading, because the intensity of the light is so low. For this reason, bracket the exposure over a wide range with the camera set at a specific aperture (for example, $f/5.6$). Vary the exposure time by using 15-second, 30-second, 1-minute, 2-minute, and 3-minute exposures. The amount of time that works best will be greatly influenced by the exposure index of the film you use. It's a good idea to pick a specific film and stay with it. Keep good records of the exposure times that work best, and before long you'll be able to determine the correct exposure for most situations with ease.

You can also experiment with materials other than glue. Textured glass or plastic can yield some fascinating patterns. Put IMAGINEERING to work again. It will prove most rewarding.

A LITTLE SCIENCE, DARKROOM MAGIC, AND SLEIGHT OF HAND—PART I

Do you remember your final exam in high-school algebra? All during the year you studied various ways to solve equations, and on that final test you had to use the right method with the correct equation. We are, in a way, at that stage now. Several techniques have been described and illustrated, each of which can provide some pretty far-out pictures. However, some of these procedures can be combined with other well-known photographic techniques to produce pictures with extraordinary impact.

There is one process known as solarization or the Sabattier effect. This technique has been discussed in several Kodak publications. Articles that describe the process in great detail are contained in *Creative Darkroom Techniques*, KODAK Publication No. AG-18 (pages 212 through 229), and *The Ninth Here's How*, KODAK Publication No. AE-95 (pages 64 through 81). Basically, the Sabattier effect is achieved by re-exposing a piece of film during its development. The re-exposure causes a partial reversal of some of the colors or tones (both positive and negative images form in the final picture). In addition, interesting line images, called Mackie lines, form between areas of extreme contrast.

Aberration patterns are natural subjects for the Sabattier effect. The finished product can take on an ethereal character which is hard to describe. The following six illustrations show *before* and *after* examples of aberrations that have gone through the Sabattier process. Notice how vibrant and almost fluorescent the Sabattier images are. These photographs have been among my most successful in salon competitions.

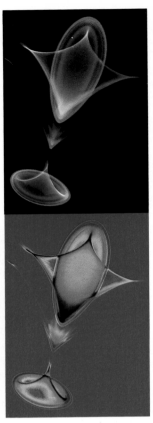

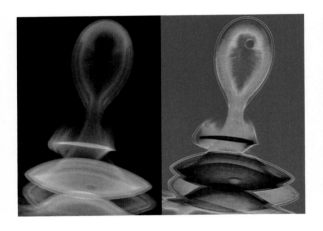

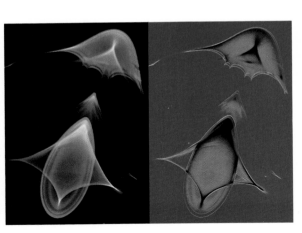

Examples of aberrations used as subjects for the Sabattier effect. The original aberration and the Sabattier image are both shown.

A LITTLE SCIENCE, DARKROOM MAGIC, AND SLEIGHT OF HAND—PART II

Dye-etch is the final technique I will discuss. This term probably sounds a little like "Double, double, toil and trouble." I assure you, there are hardly any elements of black magic in the process! Basically, dye-etch is a technique that allows you to add color to certain well-defined areas of a high-contrast lithographic film, such as KODALITH Ortho Film 6556, Type 3. This procedure can be extremely useful in working with aberration images, as additional color can be added to bright (clear) areas that show up in a slide. This technique isn't limited to aberrations. Color can be added to any slide with annoying highlight areas.

The Mechanics of Etching KODALITH Film

An aberration with an interesting structure is shown in the illustration below. However, it also contains an excessively bright area (or hot spot).

Through dye-etching I added color to a piece of KODALITH Film and then sandwiched it with the original transparency to form a stunning improvement over the original slide.

In the following paragraphs, I'll describe step-by-step the procedures you can use to arrive at similar impressive results.

The KODALITH negative. The first step is to make a KODALITH negative from the original transparency. Cut a 4 x 5-inch sheet of KODALITH Film into quarters to get maximum usage from it. Do this in a darkened room. Because this film is orthochromatic and sensitive only to blue light, a dark-red safelight can be used so that you can see for easier cutting.

Remove the transparency from its mount and place it onto the KODALITH Film, emulsion to emulsion. A printing frame or two large pieces of clear glass can be used to hold the pieces of film in direct contact. Typical light sources for exposing the film are lamps and enlargers. The exposure

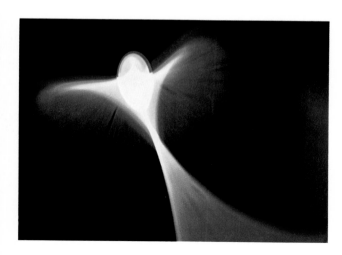

This is an aberration with interesting structure. But it also contains an excessively large, bright zone. Through the application of dye-etch, color can be added to this clear area.

time will vary according to the intensity of the light source and its distance from the film. It must be sufficient to provide completely black tones in the areas that were clear in the slide when the film is developed for 2½ minutes in KODALITH Liquid Developer or KODALITH Fine-Line Developer. A red safelight may be used during processing also, and the progress and completeness of the development observed. The following illustration shows the KODALITH negative I obtained by contact-printing my original transparency. If I had put this negative into registered contact with the slide film, all of the light areas of the slide would have been canceled or blacked out. This effect—called derivation—can be interesting by itself. However, I was after additional color!

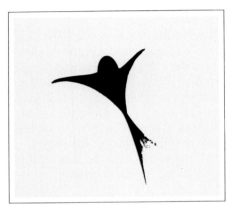

KODALITH negative

KODALITH positive

The KODALITH positive. After the KODALITH negative is dried, it should be contact-printed with another piece of KODALITH Film, using the same procedure as with the negative. The one exception is that a *nonhardening* fixer must be used. Eastman Kodak Company doesn't market a nonhardening fixer. However, you can make your own with chemicals readily available through photo dealers. Mix 240 grams of KODAK Sodium Thiosulfate (pentahydrated) with 500 millilitres of water at about 125°F (52°C). When the crystals have gone into solution, add water to bring the volume to 1 litre.

The fixer should be used at about the same temperature as your developer and wash water—preferably around 68°F (20°C). After the film is fixed, all the remaining steps can be accomplished in normal room illumination.

You will now have a KODALITH positive. The areas that were light on the slide will be light or clear on the KODALITH positive, as shown in the illustration that follows. It is this piece of film that will be subjected to the etching bath.

How etching works. The etching solution works in a remarkable manner. Wherever metallic silver has been deposited in the image (the dark areas of the film), the etching solution will dissolve both the silver and the gelatin. In the etched areas, only the plastic film base will remain. In the areas of the film that were initially clear, no etching takes place because there is no silver. (Remember—these clear areas correspond to the light areas of the original slide.) The gelatin in the clear areas, unaffected by the etching solution, will later act somewhat like a sponge to soak up dye.

The etching solution. Two stock solutions are combined to form a working solution of etching bath.

The working solution consists of equal parts of Solutions 1 and 2. I have found that 80 to 100 mL of each solution mixed together is enough to etch 8 to 10 small KODALITH positives.

The etching process. Mix the two parts of the etching solution *only* when you are ready to *start* etching your positives. Clear-glass dessert dishes work best for the etching process. These inexpensive dishes require a minimum of solution and clean easily.

Immerse the KODALITH positive in the etching bath. After 2 or 3 minutes, the silver and gelatin will start to come off. Use a cotton swab moistened in the solution to remove all the black sludge from the film; then rinse the film in running water for 15 to 30 seconds.

At this point, the film will appear to have nothing at all on it. Actually, as described earlier, there will be a thin coat of gelatin in what were the clear areas of the positive image. It is in these areas that the dye will be absorbed to provide the effect you want.

Stock Solution No. 1	
Water, about 125°F (52°C)	750 millilitres
Cupric chloride*	10 grams
KODAK Citric Acid (Anhydrous)†	10 grams
Cold water to make	1 litre
Stock Solution No. 2	
Hydrogen peroxide (3-percent)‡	

*Available from chemical-supply houses
†Available from photo dealers
‡This is pharmaceutical grade, available in drugstores as a 3-percent solution.

Acetic-acid bath. Make a 5-percent solution of acetic acid by adding 50 mL of KODAK Glacial Acetic Acid to 950 mL of water to make 1 litre of solution.

> **WARNING:** Glacial acetic acid can cause severe burns. Handle with care and follow the instructions on the bottle. ***Always add the acid to the water.*** Adding water to the concentrated acid can cause a chemical reaction that results in splattering of the acid and the possibility of serious burns.

Place the etched film into a small dish containing the acid bath and let it soak for several minutes. This will cause the gelatin remaining on the film to swell so that it will accept dye readily.

Remove the film from the acid bath and place it onto a sheet of glass or plastic with the etched side face up. (Protect the areas around the glass sheet from running or spattering dyes.) You can easily detect the contours of the etched side by gently running the pads of your fingers over the surface of the film.

Applying the dye. A variety of water-soluble dyes can be used, including ordinary food coloring. My personal preference is KODAK Retouching Colors. These can be purchased through photo dealers in a set or individual colors.

After you decide the color that you feel will enhance your original slide most, wet a small brush (similar to those used in paint boxes) with the 5-percent acetic-acid solution; then pick up some of the dye. Brush the dye onto the etched side of the film. Make several applications to obtain maximum color saturation and then rinse the film in the acetic-acid solution to remove any excess dye. *Do not* rinse the film in water afterward, because you're likely to remove some of the color. In fact, rinsing the film in warm running water is an excellent way to remove dye if you don't like the effect provided by a particular color. The same film can be reimmersed in *clean* acetic-acid solution and dyed again.

Air-dry the film if you're pleased with the color of the image after you rinse the excess dye from the film in the acid bath. Then using a light box or slide sorter, align the dyed KODALITH Film with the original slide film until the images are in register. Tape the two films together and mount them, as I did with the illustration shown at the bottom of the next page. Voilà! A rather ordinary slide has been transformed into a striking piece of imagery!

Dye-etched positive

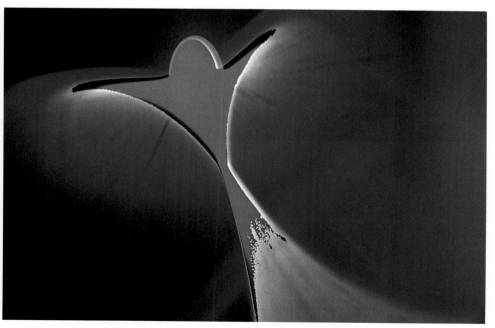

When you combine the original slide in registration with the dye-etched positive, you're likely to find an amazing transformation.

29

SOME LAST THOUGHTS ABOUT IMAGINEERING

Luke Skywalker performed some fantastic feats in the movie *Star Wars*. He had THE FORCE! You and I, as we think of Luke Skywalker, have the force of IMAGINEERING at our disposal. The techniques described in this article are but a few of many available to the adventuresome photographer. Used separately or together, the possibilities for creative images are as limitless as the universe. I have tried to act as a guide in showing how you can use these procedures in new, exciting ways. Each of you is now on your own—free to dream, imagine, and create. And it is to each of you that I say: May IMAGINEERING be with you!

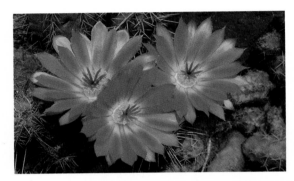

These illustrations show the transformation of an ordinary slide of some pretty cactus flowers into an exceptionally colorful slide via a variation of the dye-etch process. In this case, a dye-etched mask was used to supply the yellow centers, and another mask was made to provide the red edges to the petals.

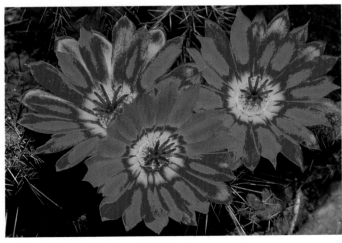

Techniques for Innovative Slide-Copying

by Keith Boas

Keith Boas is a Publications Specialist in the Consumer Markets Division of Eastman Kodak Company, where he produces books and pamphlets on a variety of photographic subjects. With a degree in photographic illustration and more than 15 years' experience as a photographer, lecturer, and writer, Keith brings a successful blend of information and visual awareness to his picture-taking publications. Some of his responsibilities include Kodak books on darkroom technique and the annual editions of the popular KODAK Desk Calendars. His editorial contributions have frequently won major awards from the Society for Technical Communication. Keith's research and photographic assignments have taken him to many pictorial locations in Europe, the South Pacific, and to 42 of the United States. His article "Producing Successful Slide Shows" appeared in The Ninth Here's How, *Kodak Publication No. AE-95.*

This article is based on a very simple premise: that you can improve nearly any color slide in your collection by making a creative copy of it.

As the darkroom hobbyist can manipulate exposure time, paper choice, filters, and enlarger height to achieve prizewinning prints, the person making copies from slides also has tremendous flexibility in enhancing an original photographic image.

Many variables come into play when you copy slides. But by paying attention to detail and using the proper materials, you can produce copies from many of your slides which are ultimately *better* than the originals.

Let's say that your original slide is of an outstanding subject but the composition is somewhat less than satisfactory. Or perhaps you were too far away from the subject when you took the picture, leaving a clutter of uninteresting visual trivia around the

31

The picture at the top shows the original slide as it was taken one cold January morning in Vermont. In the comparison picture below, I simulated moonlight by using a No. 38A blue filter over the lens when making the copy. (Increase the exposure by 2 f-stops to compensate for the density of the filter.) KODACHROME 25 Film—used to make the copy—gave the image a bit more contrast, which seems to enhance this subject.

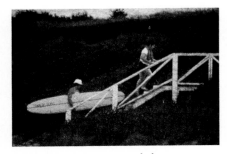

This texture effect was made by sandwiching a piece of KODAK Lens Cleaning Paper with a slide, then copying them together on KODAK EKTACHROME SE Duplicating Film, SO-366.

center of interest. Don't throw away these slides; crop them! It's easy to do with a basic slide copier and a camera with extreme close-up capability.

What about the sunset you photographed that turned out less colorful in the slide than you remembered it from real life. Copy the slide through an orange, red, or magenta filter, so you'll have all the color you want.

The techniques you can practice to improve the aesthetics of an existing color slide are indeed plentiful. In this article, I'm going to introduce you to (or give you an opportunity to brush up on) the basic equipment you'll need for making good-quality slide copies.

I'll also cover various slide copiers that you can either purchase ready-made or build yourself. And finally, I'll give you a potpourri of creative ideas that you might like to try when copying your own slides. In addition to cropping and/or adding filters, we'll jump into such topics as using lens attachments for creative copying effects, sandwiching originals together, using the best film for copying, and using partial filtration to vary color or density in specific portions of a picture.

Sound interesting? Okay, let's get started.

SELECT THE RIGHT EQUIPMENT

To successfully copy slides, your camera and lens must have the ability to focus an image on film that is the same size or larger than the object being photographed. To make a same-size (1:1) copy from an original 35 mm slide, your camera optics would need 1:1 magnification capability. (The size of the original equals the image size on the film.) To carry this further, 2X magnification would have the size of an object in the film image being twice as large as the original object. All you need to achieve 1:1 or greater magnification is a normal lens (about a 50 mm lens for a 35 mm camera) and some means of extending the distance between the lens and the film plane. As you move the lens farther from the film plane, you'll be able to get nearer objects into sharp focus. To make the illustrations for this article, I used a 35 mm single-lens reflex (SLR) camera with a bellows-focusing attachment between the camera body and the normal 55 mm lens. Most bellows devices will extend a normal lens to a distance great enough to produce sharp images at a 3X or larger magnification. You can also use several extension tubes between the camera body and lens to accomplish the same close-focusing result.

Macrofocusing lenses are very popular and work on the principle of a built-in extension tube. However, to use a macrolens for copying slides, you'll still require some additional lens extension.

In addition to the correct camera and optics, you should work with a light source that is consistent in color balance. I prefer using an electronic flash unit because it will always deliver the same high intensity of illumination, allowing me to use a small *f*-number for greater depth of field. I can also count on my electronic flash to fire a surge of light that will consistently have the same color temperature. Photoflood illumination also represents a reliable light source. However, its lower brightness level requires longer exposure times, which increase the chance of unsatisfactory results due to camera motion and possible reciprocity failure of the film.*

Between the slide to be duplicated and the light source, you must have a diffusion screen of some sort to scatter the light, providing even brightness over the entire surface. Commercially available slide-duplicating units are usually equipped with some form of diffuser. If you want to construct your own unit, you can use a piece of either translucent glass (also known as smoked or opal glass— supplied by glass dealers) or thick, white, translucent acrylic plastic, such as Du Pont Lucite®.

*Most color films are designed for the typical short exposure times used in general picture-taking. At exposure times of 1 second or longer, the speed of most films will begin to decrease and color rendition will shift away from normal. These changes are referred to as the reciprocity characteristics of a film. You can correct for the reciprocity effect by using filters and increasing exposure. Recommended corrections for critical work are given on the data sheet for each Kodak color film.

Ready-made slide copiers that you can buy are usually complete as single units. Some include a built-in electronic flash unit, filter drawer, light diffuser, and a specially modified camera with a permanently attached bellows and lens. Some disadvantages are that they sell for several hundred dollars and serve only for slide copying.

Other units are less sophisticated. They adapt to *your* camera in a way that allows immediate alignment with the original slide to be copied.

If you prefer to go the do-it-yourself route, you'll need a dependable, easy-to-operate camera support. The setups in the following pictures show a camera being used on a copystand and a camera clamped to a homemade, horizontal copying device that I constructed in my home workshop. (See plans and instructions that follow.) Each has certain benefits from a convenience standpoint. The technique (vertical or horizontal) you follow will depend on your available accessories that will be comfortable to use. Remember that you'll probably be spending a lot of time looking through the viewfinder once the creative-copying bug bites.

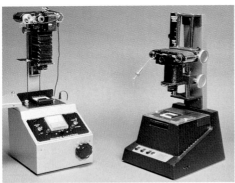

Some commercially made slide-copying devices, including these, have a built-in light source, filter drawer, and light diffuser.

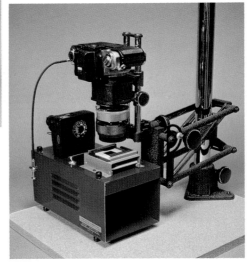

This all-purpose copystand holds an SLR camera with bellows-focusing attachment. The light box has a diffusion-reflecting system for even illumination from electronic flash. It also has a 25-watt bulb to serve as a focusing light. With this arrangement, image magnification is limited only by the capability of your lens-extension system.

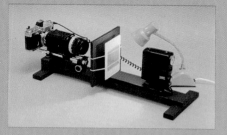 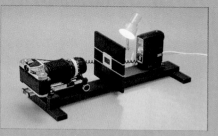

This horizontal slide-copying device consists of a single-lens reflex camera, bellows-focusing attachment, homemade bracket (see diagrams), diffuser, electronic flash unit, and rubber bands to hold the original slide and filters in position.

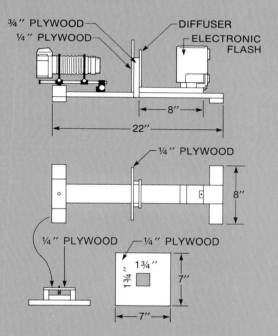

¾″ PLYWOOD
¼″ PLYWOOD
DIFFUSER
ELECTRONIC FLASH
8″
22″

¼″ PLYWOOD
8″

¼″ PLYWOOD ¼″ PLYWOOD
1¾″
1¾″
7″
7″

HORIZONTAL SLIDE-COPY STAND

With a minimum of hardware, a few plywood scraps, and a diffusing sheet, you can construct your own slide-copying device. Purchase a 1-inch bolt (¼ x 20), nut, and washer at your local hardware store to secure your camera/bellows/lens to the frame. For a diffuser you can use a piece of translucent glass or plastic, cut to fit. To cut out the square opening in the vertical easel, use a saber or keyhole saw. Adjust all of your vertical measurements to match the heights of your own bellows attachment and electronic flash.

The horizontal track supporting the slide/diffuser/flash assembly is extra long so that the unit can also be used for copying type, artwork, photos, and other flat-plane subjects that are larger than 35 mm slides.

FILM CHOICES

KODAK EKTACHROME SE Duplicating Film, SO-366

As its name indicates, here's a color reversal film designed specifically for making duplicates from original transparencies. This film is recommended primarily for exposure with electronic flash and the appropriate filtration shown on page 39. It is available in 135-36 magazines and 135-size long rolls for bulk loading. I prefer the 36-exposure magazines as I rarely have exceptionally large numbers of slides to copy. Also, the ready-to-load magazines are very convenient.

KODAK EKTACHROME Slide Duplicating Film 5071

This slide-duplicating film is designed primarily for exposure with 3200 K tungsten illumination. However, electronic flash can be used with the appropriate filtration. (See page 39.) It's available in 135-36 magazines and 35 mm and 46 mm widths in long rolls.

If you are going to purchase several rolls at one time, it's a good idea to refrigerate or freeze the film until you use it. Cold storage protects the film from color shifts which can occur in normal-room or higher temperature conditions over a period of time. It's important to maintain this consistency in color balance if you want to closely match your copies from roll to roll, using the same color-filter pack. Be sure to allow time for the cold film to warm to room temperature before you open and use it.

Also, keep any exposed film cool and dry and process it as soon as possible after exposure to avoid undesirable changes in the latent image. Both films can be processed in KODAK Chemicals Process E-6, either by a photofinisher or by yourself. For details on processing KODAK EKTACHROME Films (Process E-6), see *Basic Developing, Printing, Enlarging in Color*, KODAK Publication No. AE-13.

KODACHROME 25 Film (Daylight)

While not intended to be used for slide-copying, KODACHROME 25 Film produces favorable results for many slide-copying situations in which you don't mind a slight increase in contrast and color saturation. This increased-contrast characteristic actually makes the film ideal for bringing life to copies of flat-lighted, dull-day originals. I also like to use KODACHROME 25 Film for copying abstracts in which the increase in contrast can add an accent to subtle hues in the composition.

Since the film is balanced for daylight or blue flash, it adapts well to slide-copying devices having electronic-flash light sources. Depending on your particular equipment, filters for correcting color balance might not be needed; however, I've found that with *my* flash unit and diffusion screen, I prefer a slight filter correction for exacting work. (See the table on page 39.)

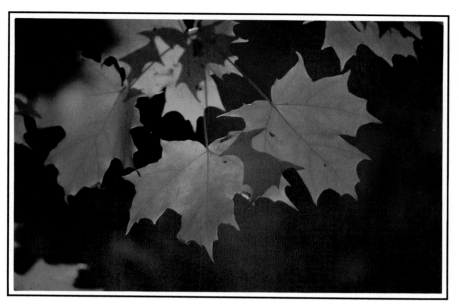

Original slide

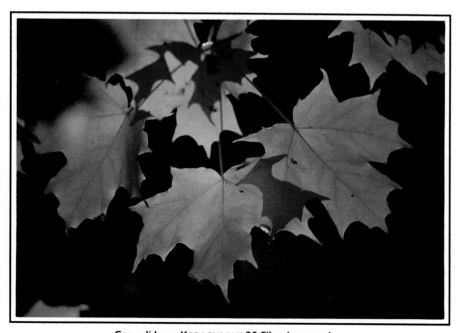

Copy slide on KODACHROME 25 Film. Increased
contrast has given more brightness to the leaves
but nearly eliminated the dark background detail,
which may or may not be favorable, depending on
the mood you're trying to achieve.

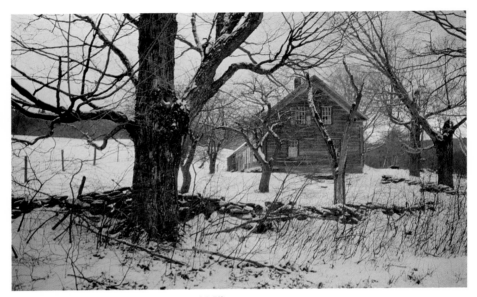

Original slide on KODAK **E**KTACHROME 64 **Film
(Daylight). Heavy overcast and lack of color
produced a flatly lighted, nearly monochromatic
scene.**

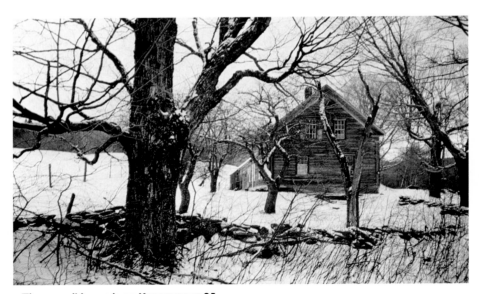

The copy slide, made on KODACHROME 25
**Film. Contrast has increased, helping brighten
the sky and snow. Dark tones have become more
saturated, giving snap to the scene.**

ESTABLISH A STARTING POINT

Before attempting to enhance the image of your original slide toward a more colorful or otherwise more interesting end product, you should first know what is required to produce as near a match to the original as possible. Expose a test roll of film with your copying setup to determine (a) the ideal exposure for a 1:1 duplicate and (b) the correct filter pack for your particular light source, diffuser, and film. Choose a standard slide to copy that has a full range of tones from white to black and a good neutral (midtone) area such as a flesh tone, gray wall or sidewalk, or standard gray card. (The KODAK Neutral Test Card, KODAK Publication No. R-27, makes a good reference subject.) With electronic flash as your light source, make an exposure series in full-stop increments from $f/2.8$ to $f/22$. Keep good records—you'll want to refer to them later when the film has been processed and the copy with the best exposure has been selected.

You'll also need to expose the copies through an ultraviolet (UV) absorbing filter, such as a No. 2B, and some color-compensating (CC) or color-printing (CP) filters to match the color balance of the original slide. (Use CP filters in front of the light source, not in front of the lens.) Through trial and error, I've found that the filter packs listed in the following table work well with my particular electronic flash and duping setup.

Your own setup will vary, of course, but a filter pack similar to one of these should put you on the right track. Once you've selected the copy slide having the best exposure, take a close look at the midtone area I mentioned earlier. Does its color match the color of the same area in the original slide? If not, decide what color seems to be too strong. For example, if the midtone appears to be slightly bluish, add a filter of its complementary color (yellow) to the filter pack. On the next roll of film, make a copy of the same original slide (your standard slide). This time use your corrected filter pack and selected f-number. You'll be surprised at how close the color balance will come to matching the original.

Starting Filter Pack	
KODAK EKTACHROME SE Duplicating Film, SO-366, and KODAK EKTACHROME Slide Duplicating Film 5071	2B + CC110Y + CC20C
KODACHROME 25 Film	2B + CC10R

IMPROVE YOUR IMAGES

Once you've established your exposure with a filter pack that produces an acceptable copy, you can then start having some fun. If you don't like the color of a sunset in an original slide, place an orange or magenta filter into your existing filter pack to warm things up. To get exactly the density you want when you use deeply saturated filters, bracket the exposure to overexpose in ½-stop increments from your established f-stop. For example, bracketing has shown me that I must increase my exposure about 1 f-stop to offset the light absorption of a No. 22 (deep-orange) filter. Do you want to turn a colorless daylight scene into a mysterious night scene? Use a blue filter when making your dupe. (I like the effect of a No. 38A filter with an exposure increase of about 2 f-stops.)

You might also like to try vignetting to remove unwanted elements around the subject in the original slide. Vignetting will help direct more attention to the center of interest. Cut a small hole in a sheet of black construction paper. Then carefully position the paper at a point between the lens and the original slide. Determine proper placement by looking through the camera viewfinder while you have the lens stopped down to the correct f-number for normal exposure. If you want an extremely soft edge between the black vignette and center-image area, make the hole rather small (about the size of a pea) and place it close to the lens.

Original slide on KODAK EKTACHROME 64 Film

Copy slide on KODAK EKTACHROME Duplicating Film exposed through a No. 22 filter. Exposure was increased by 1 stop to allow for the light absorption of the filter.

40

Daylight film produced a pleasant rendition of this floodlighted building. But the overall color of the scene is too red.

To neutralize the reddish tint and make the building appear closer to normal in color, I made my copy slide through a CC50C (cyan) filter pack.

Cropping

To crop (enlarge) a portion of your original slide, you must move your camera closer than the distance for a standard 1:1 magnification. As you increase the magnification, the film-to-lens distance must increase to keep the image in focus. This increase will require additional exposure because the light passing through the optical system and extension chamber spreads (like the beam of a flashlight) on its way to the film. The image becomes dimmer as it grows since the same amount of light must now cover a larger surface area. To determine the correct exposure compensation for electronic flash, check the instructions supplied with your lens-extension device, follow one of the methods detailed on pages 32 and 33 of the KODAK *Master Photoguide*, KODAK Publication No. AR-21, or just remember the following table:

Magnification	Exposure Increase
1:1	None (Use basic exposure established earlier with your test roll.)
2X	1 stop
3X	1½ stops
4X	2 stops

Cropping can add impact to slides by isolating and emphasizing the center of interest. At **2X** magnification you can even make a vertical picture from a portion of the original horizontal image.

Original slide

1.8X magnification on KODAK
EKTACHROME SE Duplicating
Film, SO-366

As magnification increases when making copies, so do bellows
extension and the need for additional exposure to
compensate for the dimmer image.

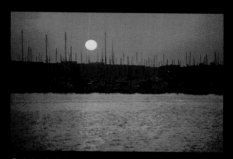

Original slide on
KODACHROME 64 Film—
photographed through a
red filter

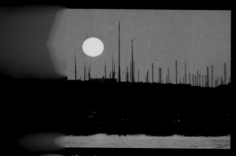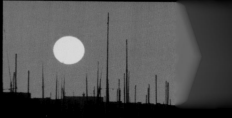

magnification copy on KODACHROME 25
(right). The increased lens extension
an exposure setting of f/5.6 with
ent: 1 stop more than normal for

A 3X-magnification copy on KODACH
25 Film. Exposure was f/4 (2 stops m
than normal).

Original slide on KODAK
EKTACHROME 160 Film (Tungsten)

Three exposures at three different
magnifications on a single frame of KODAK
EKTACHROME SE Duplicating Film, SO-366

Again, three exposures were made at three
different magnifications for this multiple-
image copy. Only this time, I moved the
original slide slightly after each exposure in
addition to increasing the magnification.

Multiple Exposures

If your camera has multiple-exposure capability, you can try all sorts of imaginative combinations for making new slides from old ones. It's usually best to work with originals that have dark backgrounds so that one image exposed on top of another will not wash out (overexpose) the important details of either one. Multiple exposures of images with dark backgrounds or exposures that do not overlap in the final copy slide produce striking results because each image is distinct. When images overlap though, the results are less dynamic. In addition, overlapping images require exposure compensation because more than one image will be sharing the same light-sensitive area on the film. To fix this in your mind, think in terms of building up images over darker backgrounds. You can't record a good image on a piece of film that already has received considerable exposure. Therefore, you'll want to decrease each exposure to keep the total buildup at a level of acceptable exposure. Here's a handy table for determining exposure compensation when making overlapping, multiple exposures:

Number of Exposures on Same Frame of Film	Decrease Each Exposure by
1 exposure	0
2 exposures	1 *f*-number
4 exposures	2 *f*-numbers
8 exposures	3 *f*-numbers
16 exposures	4 *f*-numbers

By making more than one exposure on a single frame of duping film, you can devise hundreds of combinations. Vary your selection of original slides, the magnification, the exposure, and/or the color balance. To see a tiny selection of the nearly endless number of possibilities that can be tried, take a look at the examples that follow.

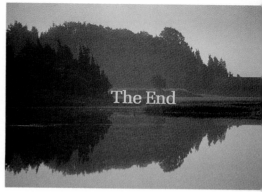

To add the title to this Cape Cod scene, I made a double-exposed duplicate slide. After making a normal exposure of the original slide, I cocked the camera shutter without advancing the film. Then I made a second exposure—this time photographing a slide with yellow letters (The End) against a black background. Only the letters recorded on the exposure.

The original slide—a 30-second time exposure on KODAK EKTACHROME 160 Film at f/8

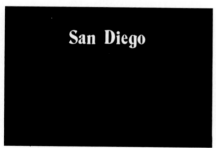

After setting the words (made with transfer letters) onto white paper, I copied them using KODALITH Ortho Film (available in sheets and 100-foot rolls, 35 mm). Next I processed the film in KODAK DEKTOL Developer, diluted 1:1, for 2½ minutes at 68°F (20°C). The result is a high-contrast negative.

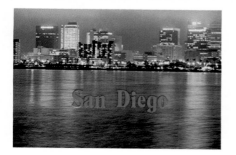

The final copy is a double exposure. I exposed "San Diego" through a No. 25 red filter to get the colored lettering. (Increase the exposure by 2 f-stops to compensate for the density of the filter.)

Original slide (sunrise—Nassau, Bahamas)

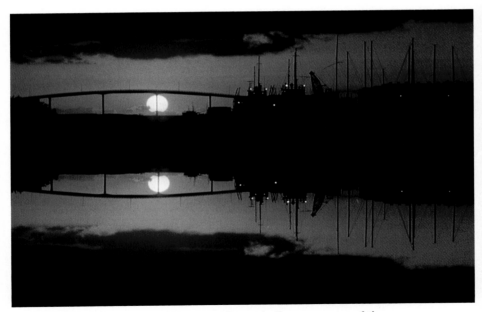

To create this double-exposure image, I made two duplicate exposures of the original slide (above). For the second exposure, I turned the original slide upside down and carefully repositioned it in the copier gate so that horizon lines in the double exposure would not touch or overlap. You can simulate reflections like this with many slides that have the horizon in silhouette. If any unwanted foreground image is present in the original, cover that portion with a piece of black construction paper or opaque tape before making the two exposures. The area covered will receive no exposure, so will turn out black in the resulting copy.

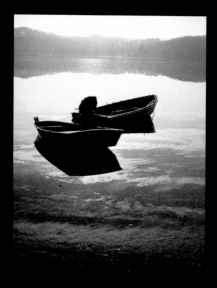

The two original color slides

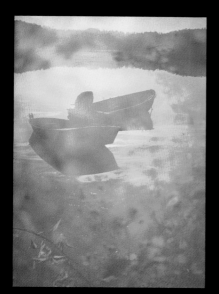 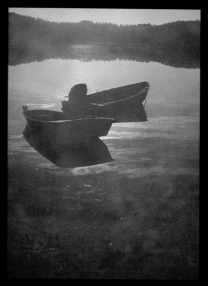

Double-exposed, copy slide with each exposure decreased ½ stop from normal f/8 to prevent overexposure in the final result. (Boats—f/9.5. Foliage—f/9.5.)

To change the effect, I decreased the exposure of the foliage slide by 2½ stops to make this image darker and more subdued. I kept the boat exposure at ½-stop darker than normal. (Boats—f/9.5. Foliage—f/19.)

Split-Field Filtration

As I looked for some general scenic pictures in my slide files not too long ago, I began to notice a definite lack of beautiful blue-sky images. (That's what I get for not living in the Sun Belt!) But I did have many slides that were taken on cloudy-bright days in which soft shadows and washed-out skies predominated. Here's an oppor-tunity, I thought, where some selec-tive, split-field filtering would improve an original image, producing a copy slide with any amount of additional color I desired, nearly anywhere I wanted to put it. So I tried making some copies using the split-field filter method. I immediately discovered how much fun it was, how easy, and how good the results can be.

Normal scene (original slide)

To add color to the sky, I made a copy with **CC70C (cyan)** filtration over just the top half of the image.

The exaggerated blue sky was produced by placing a **No. 44A** filter partway in front of the lens while making the copy slide. (Increase the exposure by 2⅓ f-stops to compensate for the density of the filter.) The horizon line hides the rather blunt edge of the filter.

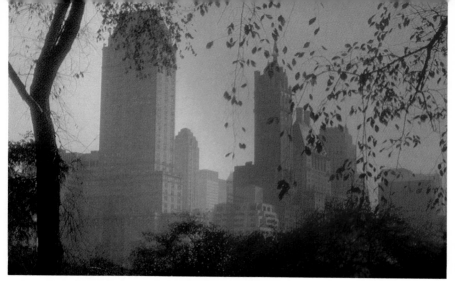

This slide was copied through a 3 x 3-inch sheet of flexible acetate which had been hand-colored with red and blue marking pens.

For this localized-filtering technique, I generally prefer to use gelatin filter squares—either the pale, color-compensating filters or the more saturated ones designed primarily for black-and-white photography.[*] Gelatin filter squares give you the flexibility of changing or adding color in only a part of the copy slide being made. To change or darken the color of the sky in your copy, for example, place a gelatin filter over part of the lens, filtering only the sky. Or you can slip the filter only partway into the filter drawer of your copying setup. Base your exposure on the nonfiltered area of the scene. This means that if you are filtering only part of the original slide (i.e., the sky), you won't have to make any exposure compensation. The resulting sky area in the copy slide will be the only part of the image affected by the absorption of the filter.

Perhaps you might like to experiment with making copies through a sheet of clear acetate (available at art-supply stores) that you have colored with ordinary felt-tipped, permanent-ink marking pens. Just cover the surface of the acetate sheet with your favorite colors. Then place the sheet directly in front of the camera lens to make your exposures. It is difficult to achieve *deep* color saturation from marking-pen ink when it's spread on acetate. Therefore, to make the resulting pastel shades more obvious, choose original slides that have light-colored subjects or subjects against a white background.

[*]Gelatin-film squares are the least expensive type of filter—a 50 mm (2-inch) square usually sells for about $3.50. The selection of colors and densities is also outstanding. KODAK WRATTEN Filters, for example, are available in more than a hundred varieties, in 50 mm, 75 mm, and 125 mm gelatin squares.

The next time you get the urge to create new and wondrous visual images on film, don't feel that you have to wait for the right day, perfect model, or unique setting to come along. Just go to your file of existing slides and pick out 20 or 30 favorites that, for one reason or another, never quite made the top grade. Then gather a few filters and lens attach-ments, conjure up a little imagination, and turn to your slide-copying equipment and begin creating some new works of photo art. You no longer have to consider the originals you took in your camera as the end results of your photographic skills. Instead, they can be the beginning step in the process of making new *and better* color slides.

To create the sandwich of the birds and tree against the huge sunset—

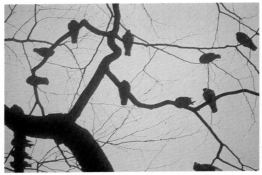

(1) I first made a copy slide on KODAK EKTACHROME Film of a 16 x 20-inch black-and-white enlargement.

(2) Next I photographed a sunset with a 410 mm lens focused at about 7 feet to blur and enlarge the image of the sun.

(3) Since the image of the sunset was still smaller than I wanted, I then made a cropped copy of it on KODAK EKTACHROME Slide Duplicating Film 5071.

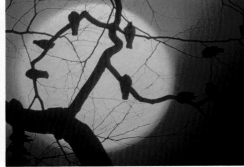

(4) My final step was to sandwich the birds-in-tree copy slide with that of the larger sunset.

PHOTOGRAPHING THE SKY—
How To Capture Its Beauty and Variety on Color Film

by Henry Lansford

Henry Lansford describes himself as a writer who learned to use a camera when he needed pictures to illustrate what he wrote. His interest in photographing the sky grew out of his work at the National Center for Atmospheric Research, in Boulder, Colorado, where he was information officer from 1965 to 1978. He is currently doing free-lance writing assignments and working as a communications consultant to the National Oceanic and Atmospheric Administration, the American Meteorological Society, and other scientific organizations.

Lansford's photographs have appeared in a variety of publications, including National Geographic, Reader's Digest, Natural History, and Science News. His photos have appeared in the weather segment of the Today show on NBC Television and in exhibits and publications on atmospheric research and other subjects.

Lansford is the author of about 100 magazine articles and other publications and co-author of the book The Climate Mandate, published by W. H. Freeman and Company. His wife, Neville, and his sons, Tyler and Lewis, help him keep an eye on the sky; and he credits them with having spotted many of the clouds that appear in his photographs.

51

The sky has held a fascination for the human race throughout history. It has a mysterious unknown quality, often revered and admired—sometimes feared. How many of us as children spent countless hours reclining in a field of grass and imagining all sorts of things in the shapes of the clouds passing overhead?

So the process of trying to capture the images in the sky is only natural. And it can be fun and rewarding in many ways.

There are several good reasons why I started looking for camera subjects in the sky. My first reason was very sensible and straightforward: as information officer for the National Center for Atmospheric Research, I wanted to build a collection of photographs of the kinds of clouds that can be seen in the sky over Colorado.

But it wasn't long before I became fascinated with the beauty and variety of the shapes and colors that I saw through my camera lens, and I started trying to capture those qualities on film along with the meteorological characteristics of the clouds. I began shooting skyscapes just as many photographers shoot landscapes.

Finally, I discovered something about sky photography that should challenge any photographer who takes the craft seriously. When you photograph the sky, you are dealing very directly and intimately with the raw material of the photographic image—light. Every object that you photograph—a human face, a flower, a mountain—is defined on film by the ways in which it reflects, transmits, and absorbs light. But clouds and raindrops are much less substantial than people, vegetation, and rocks, and the light that reaches your camera from the sky is much more intense than the light that is reflected from terrestrial objects. Thus when you shoot the sky, you come as close to photographing light in its purest form as you can with any subject that exists.

WHERE CAN YOU SHOOT THE SKY?

There are some places where spectacular and photogenic things happen in the sky very frequently. South Florida has more towering thunderheads than any other place in the United States. Arizona's dusty desert sky produces incredibly brilliant sunsets. Boulder, Colorado, where I live, is where the Great Plains meet the Rocky Mountains, bringing together a combination of topographic elements that produce a great variety of action in the sky in every season. However, if you were to go to one of these places for the express purpose of photographing clouds, you might well be greeted by a week or two of cloudless blue skies.

Sky photography can't be scheduled or programmed. But if you're going to Florida, Arizona, or Colorado for business or pleasure, by all means take along a camera and watch for the local meteorological specialties. Because there is a potential for beautiful sky pictures wherever an expanse of sky is visible, you'll probably do much better by keeping an eye on atmospheric conditions in your own area.

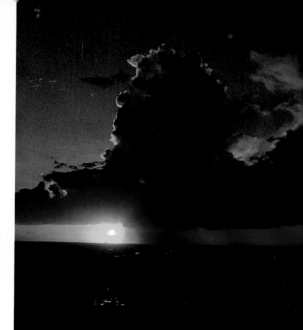

More thunderstorms occur over southern Florida than any other part of the United States. This thunderhead was photographed over the Everglades west of Fort Lauderdale just before sunset.

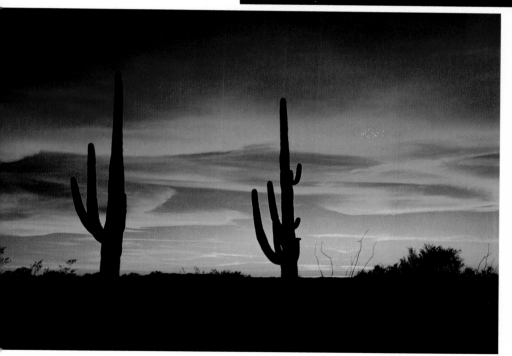

The dusty desert air over southern Arizona filters out the blue light at that end of the spectrum, leaving the red to produce spectacular sunsets.

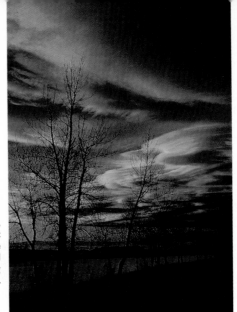

These wave clouds over Boulder, Colorado, were photographed at sunset when the last rays of the sun enhanced their color and emphasized their interesting forms.

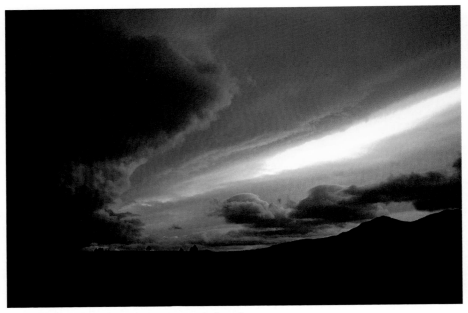

The interaction of weather systems, wind, and sunlight results in some dramatic effects in the sky over Boulder, where the Great Plains meet the Rocky Mountains.

If there's a secret to successful cloud photography, it's something like this: Look up a lot, and keep a loaded camera handy. Wherever you live, there is something exciting going on in the sky some of the time. The idea is to be outside with your camera loaded with film and pointed up when it comes along. If you live on the plains or a mountaintop, it's easier to keep an eye on the sky than it is in the middle of a big city or a redwood forest. But that's how it must be done—you have to shoot what the military men call targets of opportunity. You can't schedule a session of sky photography from 9:00 to 11:00 next Saturday morning.

When you do discover something pictorial going on in the sky, where is the best place to stand to photograph it? I have taken cloud photos from the roofs of tall buildings, from jet airliners, from hotel balconies, and from a variety of other vantage points. But my favorite spot for shooting the sky is an area of high, open ground just south of Boulder and about 5 minutes from my home. It offers a choice of horizons: endless plains to the east, mountain crests to the west, and a variety of pine trees and bare, rocky ridges nearby. By moving around, I can choose among these foregrounds. I often walk a couple of miles over an hour or so in the course of photographing two or three good cloud formations.

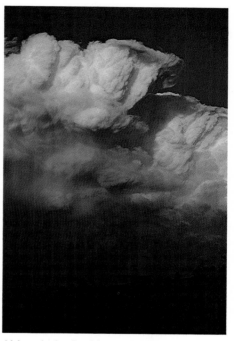

Although clouds without a horizon below tend to be somewhat confusing in a photograph, it is sometimes worthwhile to zoom in close on the structure and texture of a cloud like this thunderhead.

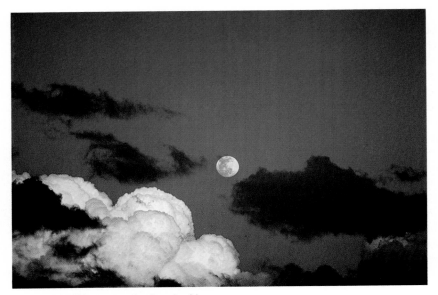

It was impossible to get a horizon in this photograph and still show the effect of a sunlit cloud top beside the full moon.

You may not have that much flexibility, especially if you live in a city or a heavily wooded area. Your best bet may be an open hilltop or a flat-roofed building. The main thing to avoid is a lot of clutter in the foreground. You need a horizon in most cloud pictures. Clouds alone have a disorienting effect and lack a sense of scale. A busy or complicated foreground can dominate the picture and detract from the impact of the main subject in the sky. An exception to this is the clever use of foreground objects used for framing the subject, such as the overhanging branches of a tree.

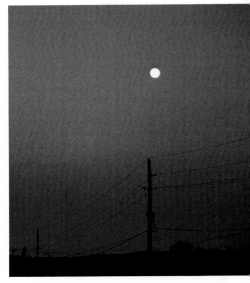

A power pole points up past the earth's shadow toward the full moon. Human artifacts like power lines, which usually provide unwanted clutter in the foreground of sky photography, can sometimes be used effectively as useful elements of a picture.

You can't always choose your foreground. Many phenomena in the sky, such as rainbows, appear and disappear very rapidly, so you have to shoot them from wherever you happen to be or not at all. A sky photograph with a busy foreground may be better than no photograph at all, or it may turn out to be one that you should throw away as soon as you see it. I believe in taking a lot of chances, shooting a lot of film, and ruthlessly tossing out the photographs that aren't good enough. If you follow this practice long enough, your intuition will become more and more refined, and you'll find yourself throwing away fewer and fewer pictures and getting an increasing number of really good ones. If you're after outstanding pictures keep one thing in mind: film and processing are probably two of the least expensive items in the venture.

The first thing to do when you get a batch of sky photographs back from the lab is to go through them and ruthlessly weed out the errors produced by the trial-and-error process that is a necessary part of sky photography. Don't keep your mistakes—they'll only embarrass you sooner or later.

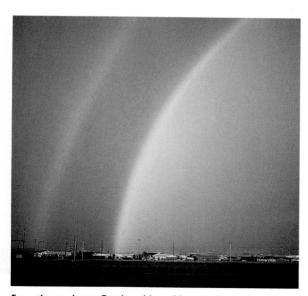

Sometimes when a fleeting thing of beauty like this double rainbow comes along, you have no choice but to break the rule about foreground clutter. I like this shot in spite of the houses and power lines.

EQUIPMENT

What equipment do you need to picture the sky? My list is short and simple—it includes some basic hardware that most serious amateur photographers already own. Here is the equipment I used to make most of the photographs that appear with this article:

A 35 mm Single-Lens Reflex Camera

Although you can get some good sky pictures with a simple camera, you can handle a variety of situations better with more sophisticated equipment. I have taken some good cloud photographs with a twin-lens reflex camera, but an SLR with a variety of lenses will help you deal effectively with the diverse and changing nature of clouds and other atmospheric phenomena. The camera does not need to be expensive with a lot of fancy features, but it should be a dependable one with which you are thoroughly familiar.

Lenses

Nearly all my sky photographs have been made with either a 35 mm wide-angle or an 80 to 200 mm zoom lens. There are some situations in which a shorter focal-length lens might be useful and others in which a longer focal-length lens could be more effective. But I do a lot of walking when I shoot the sky, and I like to keep my equipment as light and simple as I can. The 35 mm and 80–200 mm lenses do a good job for me 99 percent of the time. Recently I have been using a 70–150 mm zoom lens that is smaller and lighter than the 80–200 mm lens, and I have found that it handles most sky situations well.

When you use a telephoto lens, even the slightest camera movement can be magnified and result in blurred pictures. In such instances, it's a good idea to use a fast shutter speed, a tripod, or both.

Exposure Meter

I use a camera with a built-in center-weighted meter, although any good light meter will do the job. For many sky photographs, the meter reading is only the starting point for an exercise in looking over the scene and guessing at an appropriate exposure. You'll find yourself striving for a particular dramatic effect rather than a literal rendition of everything that your eye and the camera lens are taking in. I'll have more to say about that when I discuss techniques.

Tripod and Cable Release

Although I handhold my camera for most daytime work, there are situations when I need a rock-steady camera, such as while using a slow shutter speed or when using a lens with a long focal length. For shooting the sky at night, a tripod is a necessity. And for really long exposures at night—a minute or more—a cable release with a setscrew to hold the shutter open will save you from getting thumb cramps.

When you use a long lens without a tripod, it's a good idea to hold the camera as steady as possible by bracing your elbows on your knees like this.

Although it's inconvenient to carry, a tripod will help you get sharp pictures, especially with a long lens and low-light conditions that keep you from using a fast shutter speed.

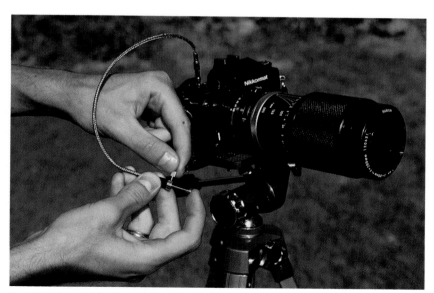

A cable release with a knurled setscrew to hold the shutter open is useful when you're making exposures of a minute or longer.

Timer and Flashlight

For night exposures of less than a minute, you can count seconds pretty accurately by the "one thousand-one, one thousand-two, one thousand-three . . ." method. For longer exposures, a timer is useful. I use an inexpensive kitchen timer from a discount store rather than one of the more accurate and costly models designed for darkroom and laboratory work. It should run for at least 10 minutes and should signal you with a bell when the time is up. A flashlight is helpful at night for setting the camera shutter speed and aperture, as well as the timer. A small flashlight with a pocket clip is practical to reduce the risk of laying it down and losing it in the dark.

Filters

A variety of filters can enhance your sky pictures. I regularly use a polarizing filter to dramatically darken the sky and emphasize the clouds when the sun is coming from the right or left at an angle of about 90 degrees. In addition, the polarizing filter can increase color saturation and cut the reflected glare from the water and other bright surfaces.

Here are some other filters that you might consider using.

- Color polarizers provide a wide range of effects, such as varying the hue of a color (single-color polarizer) from very pale to heavy saturation or for varying degrees of intermediate color that are blends of two colors (two-color polarizer).

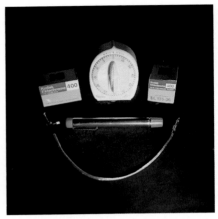

A timer, small flashlight, cable release, and a fast film are helpful for night pictures.

- Color filters can change day into night (deep-blue filter plus underexposure), create a mood, or improve an otherwise drab scene.
- Transmission diffraction gratings reveal the color spectrum of white light when you photograph scenes that have a strong point source of light, such as the sun. They are available in radial, linear, and other patterns.
- Cross screens produce an interesting star design with night scenes that have specular highlights. They are available commercially and can also be made easily and inexpensively with window-screen material.

For additional information on these and other color and special-effects filters, see *Filters and Lens Attachments,* KODAK Publication No. AB-1, available from photo dealers and bookstores.

60

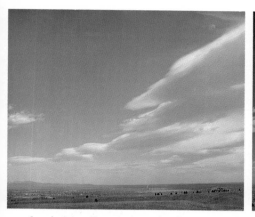 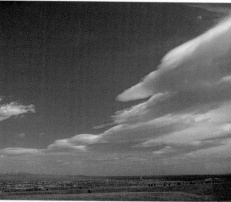

A polarizing filter darkens the sky and emphasizes the clouds. The left photograph was taken without the polarizer and the right one with it.

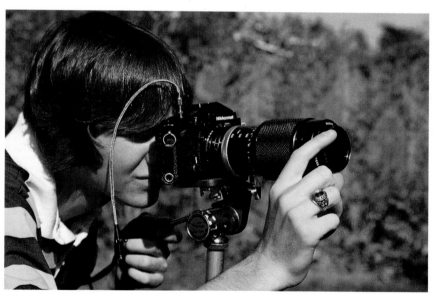

Look through the lens as you rotate a polarizing filter to darken the sky or cut the glare from water or other reflecting surfaces.

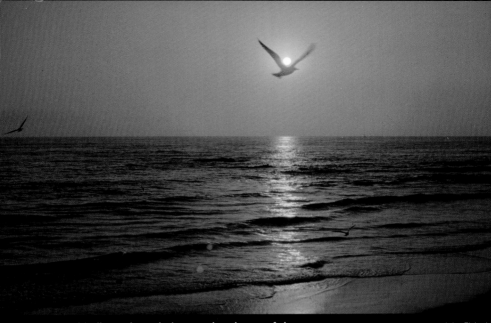

A red/yellow color polarizer produced most of the warm color in this hazy sunset.

John Fish, Jr.

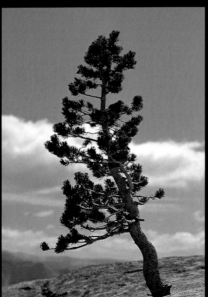

Use of an orange filter on the normal scene at the left emphasized the solitary tree and provided an impression similar to a blazing inferno in the

Herb Jones

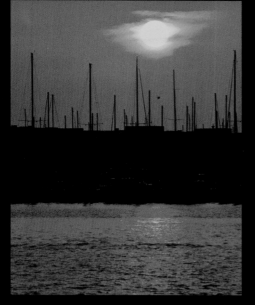

A red filter added to the effect of this harbor scene photographed near sunset.

Keith Boas

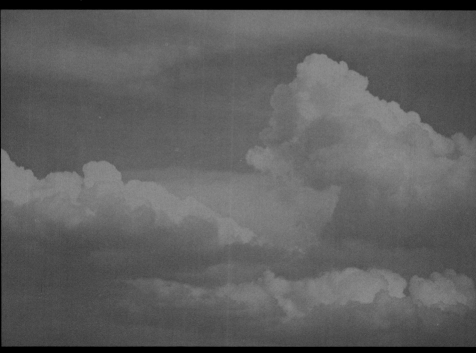

In this photo, a blue filter creates a fantasy mood of drifting endlessly through cloud-filled skies.

Keith Boas

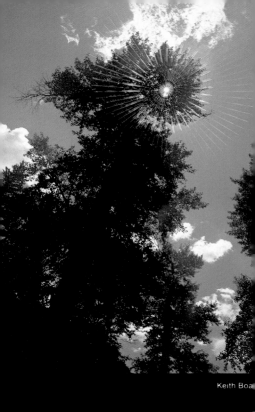

Another type of diffraction grating created this
colored streaking on clouds above the Washington

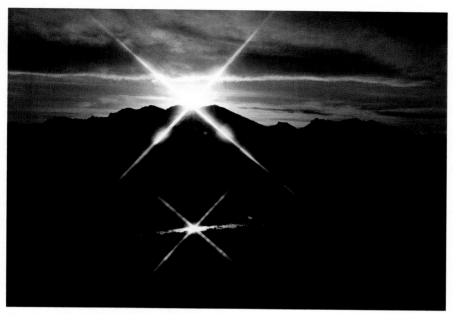

A cross screen caught the sun peeking over the mountaintop and reflected in the nearby stream to form the double star pattern shown here.

A Word About Film

I use the same film as much of the time as possible. Because I sell a good many photographs for use in magazines and other printed publications, I need a very fine-grain color transparency film that can stand a good deal of enlargement without getting too grainy.

It must also keep its contrast and color rendition through the processes of color separation and lithographic or rotogravure printing. So I use KODACHROME 25 Film most of the time. I switch to KODACHROME 64 Film when I need a little more speed, and I have had some very interesting results with KODAK EKTACHROME 400 Film at night and under other very low-light conditions. With cloud photography, there is a clear advantage in getting used to one film and using it as much as possible. The right exposure can often result as much from familiarity with the characteristics of your film, educated intuition, and experience, as from an accurate meter reading.

TECHNIQUES

How difficult is it to photograph clouds and other things in the sky? In some ways, the sky is a very forgiving subject. Practically everything except an occasional foreground object is more than 50 feet away. This means that you'll be focused at infinity most of the time and the depth of field of the lens will accommodate the majority of situations. There's usually plenty of light available, except when you're photographing the stars. Sunsets make a particularly attractive subject for the beginning sky photographer—even the rankest amateur with a

simple camera can usually get some spectacular sunset shots. But to capture some of the more varied and subtle things that happen in the sky, you may need to use a few techniques that you haven't picked up in taking pictures of more conventional subjects.

Different subjects in the sky often call for different techniques, so I'll consider several of these and the best approach for each.

Sculptures in the Sky

Clouds can be treated in many ways in photographs. In sunset pictures, clouds usually come across as vivid but essentially two-dimensional patterns of brilliant color. Clouds are often used as important but subordinate elements in landscape photos, with mountains or a scenic expanse of countryside as the main subject. But clouds can also be photographed as three-dimensional objects—"Sculptures in the Sky," as I called them in the title of a 6-page picture feature that I had in the March 1978 issue of *Reader's Digest*.

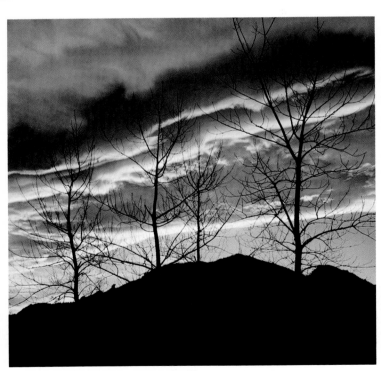

The bare trees identify the season in this photograph of winter clouds over Boulder.

The best time to photograph clouds as sculptures is in the late afternoon. This is when the clouds usually reach impressive proportions and the light strikes them at a shallow angle that dramatically emphasizes their shapes and textures. About an hour before sunset the sky darkens to a deep blue that can contrast with the warm shades of yellow and pink that may tint the masses of the clouds.

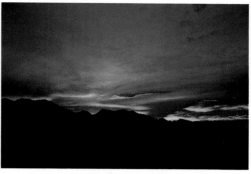

Sometimes the evening sky takes on a rich blue color that contrasts beautifully with the orange of the clouds. The contrast was emphasized by exposing for the brighter clouds rather than the darker sky.

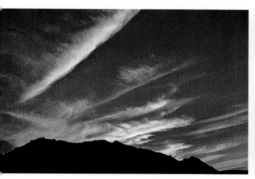

Streaks of high cirrus cloud, which would fade into the sky if photographed at midday, stand out clearly just before sunset.

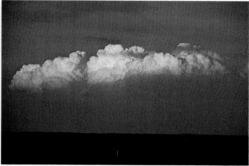

The shadow of the earth's horizon is creeping up these summer cumulus clouds as the sun sets, but the cloud tops are stained with color.

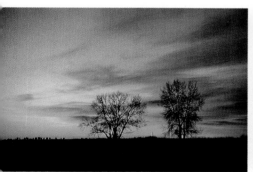

The delicate colors of the sky on this winter morning were beautiful but not very exciting. The bare cottonwood trees and black horizon bring the scene into perspective.

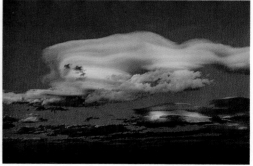

These contorted winter clouds over Boulder, Colorado, were photographed just before sunset when their rich color contrasted with the dark blue sky. I exposed for the brightest areas of the clouds.

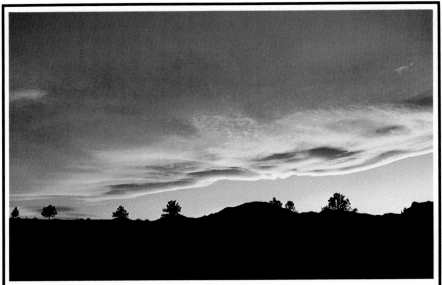

A wind-sculptured cloud is painted a rich yellow by the setting sun.

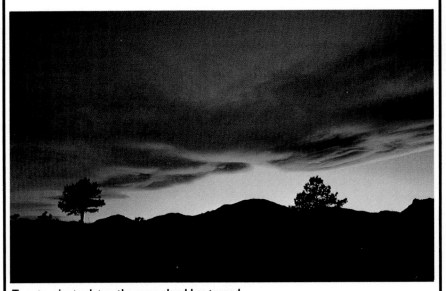

Twenty minutes later, the same cloud has turned crimson as the sun drops lower, with its light filtered by a larger stretch of edgewise atmosphere. It's worth staying with a good cloud like this one to catch it at successive stages as the light changes.

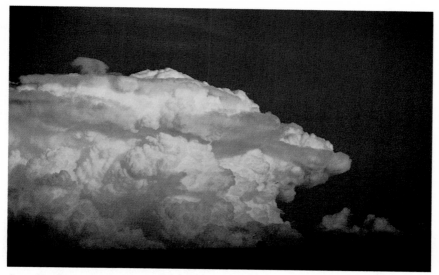

A couple of straggly little pine trees along a bare ridge contrast effectively with the enormous bulk of this thunderhead. The late-afternoon light, coming from the right at a shallow angle, accentuates the boiling structure of the cloud and deepens its color.

To reveal the shapes of the clouds as clearly as possible, try to have the sun directly to your right or left. This is also the most effective position for using a polarizing filter to darken the sky to achieve maximum contrast with the clouds. Simply rotate the filter as you look through the lens of your camera to choose the position that gives the effect you want. The normal exposure compensation for a polarizing filter is to open the lens about 1½ f-stops. If you use a single-lens reflex camera with a built-in meter that reads directly through the lens, this might not be necessary. However, in either case it is a good idea to bracket your exposure by ½ stop over and under, in addition to the *normal* setting you've determined.

A good rule of thumb for selecting an appropriate aperture for this kind of cloud photography is to scan the cloud with your meter and set your exposure for the highest reading that you get. Then shoot at the indicated setting and bracket by shooting two more frames, one at a half-stop higher and one a half-stop lower than the aperture indicated by the meter reading. This will give you a good chance of getting maximum detail in the lightest parts of the cloud.

Obviously, you can't walk toward or away from a cloud to make it fill your frame effectively. This is where a zoom lens comes in handy: it gives you an infinite number of possibilities between its minimum and maximum focal lengths. For a towering summer thunderhead or a contorted winter-wave cloud, it is often effective to zoom in so that a single cloud fills the frame or even to isolate a detail of the cloud, concentrating on its structure and texture.

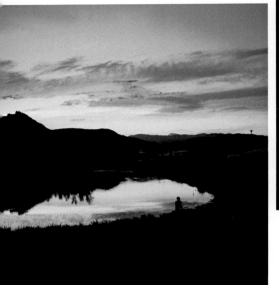

A body of water can be combined with the sky to accentuate the effect of clouds or light.

When you see unusual clouds early in the day, you can often get good photographs by waiting until an interesting one is backlighted by the sun. This combination will frequently give you a dark cloud with a brilliant silver border, sometimes accompanied by dramatic beams of light radiating outward.

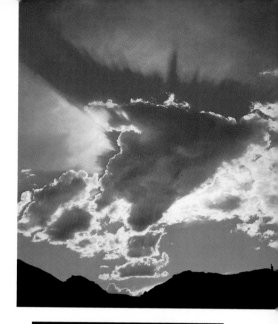

Shining out from behind a fair-weather cumulus cloud, sunlight casts a crown of shadow on a thinner cloud above.

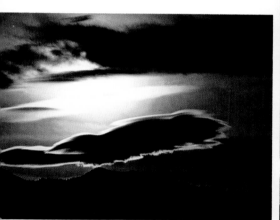

Backlighting outlines this cloud with silver and silhouettes the mountains below to create dramatic high contrast.

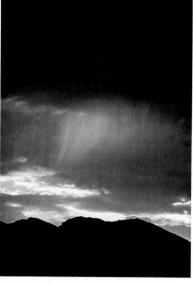

Without the backlighting from the sun, which has dropped behind the mountains, this veil of virga—rain that evaporates before reaching the ground—would have been hard to see in a photograph. Backlighting can be used to make many wispy and diaphanous phenomena visible on film.

The Sun

Photographing the sun raw—that is, the solar disc unobscured by clouds or anything else—is best left to the astronomers with their special instruments and filters. Looking directly at the sun with the naked eye or through a telescope or the lens of a camera can cause serious and permanent eye damage.

But when there's something in front of the sun to block its intense radiation, as well as to make it more interesting for photographic purposes, it can make a good subject. I have taken some interesting photographs of the sun on cloudy winter days when it had a ghostly quality almost like the moon. The sun also takes on subdued but dramatic qualities when it rises or sets behind haze, smog, or low clouds.

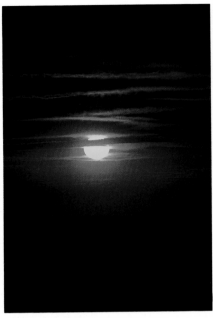

A band of cloud stripes the setting sun over the high plains of northeastern Colorado. I exposed for the disc of the sun, so the clouds are dark and the sky is black.

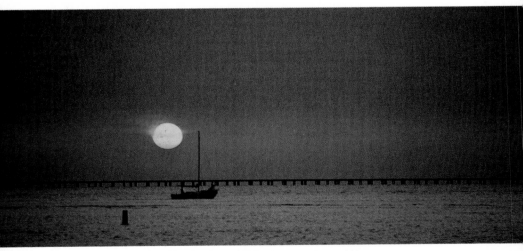

Haze over Lake Pontchartrain north of New Orleans, turns the sun into an orange disc. The boat and causeway add interest.

The contrast between the warm color of the sun and the gray of the mist and farm buildings adds interest to this photo made just after sunrise on a winter day over the Colorado Plains.

A fine pall of windblown dust from the Sahara produces a yellow sun in a pearly sky over the city of Dakar in West Africa.

Bare cottonwood branches provide an interesting pattern in what would otherwise be a dull photograph of the winter sun through clouds on an overcast day.

The lenses that I customarily use do not make the disc of the sun very big on a 35 millimetre slide. I usually use clouds, foreground objects such as a mountain slope, or a frame of tree branches to help fill the frame and make the composition more interesting.

Even when the sun is partially obscured by clouds or haze, enough of its radiation may be getting through to damage your eyes. Be careful not to look directly or through the viewfinder at the sun. My camera has two readouts for the light meter—one that you see along with the image when you look through the lens and the other in a little window on top of the camera body. I use the one on top to aim the camera when I'm shooting the sun. When the needle hits a maximum reading, I know that the center-weighted meter is centered on the sun. In this way, I avoid use of the viewfinder and the possibility of eye damage.

Rainbows and Other Optical Phenomena

The rainbow is probably the most familiar of a host of atmospheric phenomena in which the white light of the sun is reflected, refracted, or scattered in various ways that often break it down into its component colors. Rainbows, for example, are produced when sunlight is refracted into the colors of the spectrum as it passes through raindrops, then reflected back in the direction from which it came by the inside back surfaces of the drops. Thus when you see a rainbow, you will always have the sun to your back and falling rain in front of you. This means that the ground will often be brighter than the sky above, with gray cloud and rain above bright-green grass.

The colors of the rainbow are usually delicate, and they frequently require slight underexposure to show up well on film. As with many other things in the sky, you can't trust your meter too far in photographing rainbows. I usually take a reading on the sky near the rainbow, then bracket one-half and one full stop in each direction.

The same rules apply for other less familiar optical effects in the sky—iridescent clouds, coronas around the sun, and twilight rays that reach up into the sky as the sun sets behind ragged clouds or mountains.

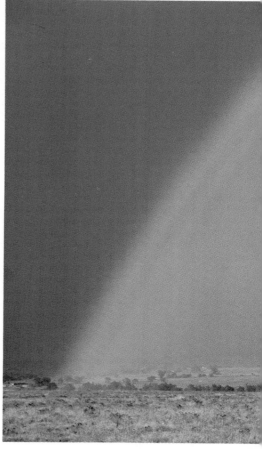

A rainbow arches up from the Colorado plains. I exposed for the darker sky and rainbow and let the sunlit ground go overexposed a little.

75

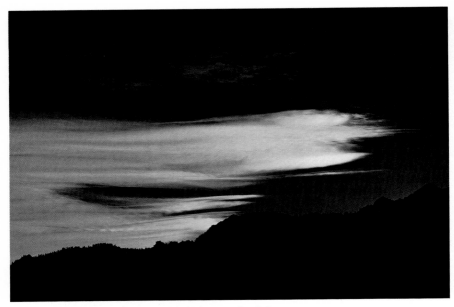

To pick up the delicate colors in this iridescent cloud, I
underexposed the mountains and sky. The colors result from
refraction of the light from the sun (which is directly behind
the cloud) by droplets or ice particles in the cloud.

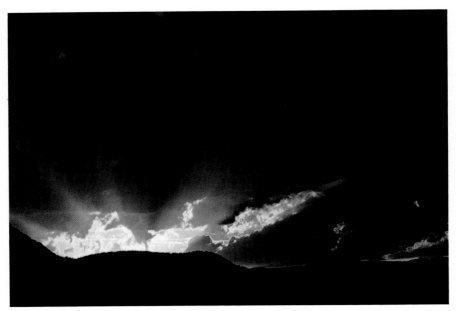

Crepuscular (twilight) rays reach up into the sky as the sun
drops behind mountains and ragged clouds. I exposed for
the bright rays, letting the sky and mountains go black.

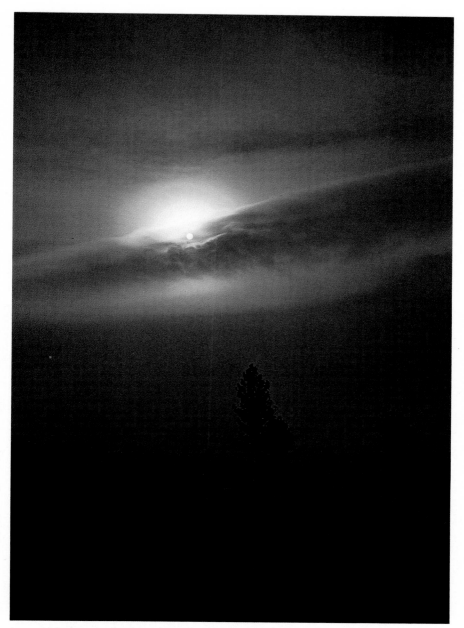

Ice particles in a cloud refract the sun's white light into a
rainbow-like corona. I exposed for the corona itself, letting
the clouds and ground below go much darker than they
appeared to the naked eye. This sort of effect can be
achieved on film only if you regard your light meter reading
as a starting point rather than a dictum.

Lightning

Lightning occurs both in the daytime and at night. But it is most easily photographed at night with a very simple technique. From a window or other sheltered spot, where you can keep your camera dry and not risk being struck by the lightning you are trying to photograph, locate an area of the sky where lightning strikes are occurring repeatedly. Mount your camera on a tripod and aim it at this area. Open the shutter using a cable release and hold it open until a bolt of lightning streaks across the sky. Close the shutter, advance the film and go through the same procedure again.

For lightning photography, a twin-lens reflex camera that uses 120-size film has a couple of advantages over a 35 mm single-lens reflex camera. The first is simply that you can see what you're getting. You can watch the ground glass of the twin-lens camera and see the position of the lightning strike that you are photographing. But with the SLR, the mirror flips up as soon as you trip the shutter, so all you can do is watch the general area at which the camera is pointed. Secondly, the lightning is likely to be off to one side of the frame, and the larger 120 format gives you more area to crop to a better composition on the negative or transparency.

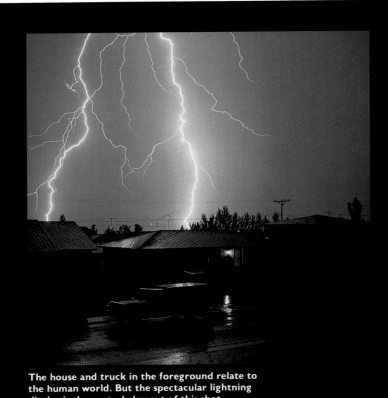

The house and truck in the foreground relate to the human world. But the spectacular lightning display is the central element of this shot.

The pictorial effect of this double lightning strike is somewhat overpowered by the mass of the highly illuminated apartment buildings.

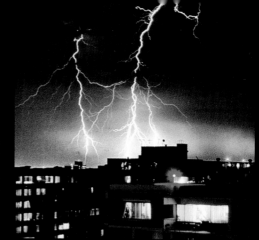

Ira Richolson

Ira Richolson

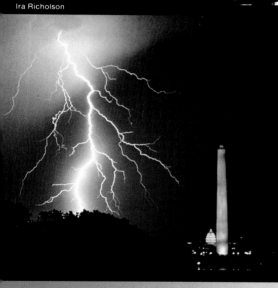

A giant lightning strike provides a startling contrast to the serenity of the Washington Monument and Capitol dome.

Michael Fairchild

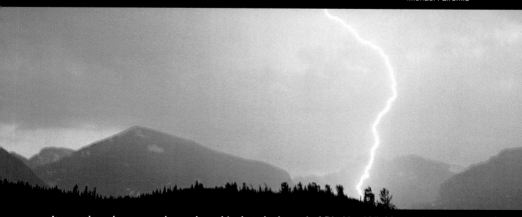

It must have been on a day such as this that the legend of Rip Van Winkle was born.

Shooting lightning is a lot like playing roulette, so you may throw away four or five shots for every good one that you keep. Even if you succeed in aiming your camera at the spot where the lightning strikes, the photograph may not turn out very well. For example, if cloud-to-cloud lightning or an overlong exposure causes the background to brighten too much, you may lose so much contrast that the lightning is no longer dramatic. On the other hand, a bright bolt of lightning against a totally black background can be uninteresting too.

If possible, avoid having too many street lights or cars in the foreground of your lightning pictures. With long exposures, car headlights and taillights will photograph as streaks as the car moves across the image area. I like a few lights, trees, or the tops of buildings in the foreground of lightning photographs. They suggest that the lightning is closely related to human concerns, which of course it is. But as with any kind of sky photography, too much clutter in the foreground can detract from the main subject of the photograph.

Aperture settings are even more in the realm of guesswork with lightning than with other subjects in the sky, as there's no way to get a meter reading even as a starting point. With KODACHROME 64 Film, I start with exposures at $f/8$ and work my way up and down.

It may take a long time for a thunderstorm to come along and pose for you in front of a convenient window, but it does happen. Several years ago, I shot a roll of KODAK TRI-X Film from my youngest son's bedroom window as a thunderstorm rampaged across the plains to the east, firing barrages of electricity toward the ground. One shot on that roll has appeared on two magazine covers and has illustrated perhaps two dozen articles on storms. It also has toured as a photomural in the exhibit "The World of Franklin and Jefferson" in museums throughout the United States as part of the U.S. Bicentennial celebration in 1976.

The Moon and the Stars
Like the sun, the moon is best photographed with some other things in the picture to add interest. The best season for shooting the moon is the autumn, when the harvest moon in September and the hunter's moon in October rise at about sunset. Photograph the moon while the sky is still fairly light. There's nothing duller than a photo of a bright disc in a stark-black sky. Under such conditions, reflections in my zoom lens give me a second ghost moon. I like to get the full moon close to the horizon in a pale gray or lavender sky, with a couple of silhouetted pine trees or a few wisps of cloud to help fill the frame. I center the moon on my meter, set the aperture on the indicated f-stop, and then bracket several exposures each side of normal.

To avoid an elongated (or smeared) appearance of the moon, use a maximum exposure of 2 seconds with a 50 mm lens, 1/4 second with a 300 mm lens, 1/8 second with a 600 mm lens, and 1/15 second with a 1000 mm lens.

For additional information on photographing the moon and stars, see *Astrophotography Basics,* KODAK Publication No. AC-48. Single copies are free from Eastman Kodak Company, Department 841, Rochester, New York 14650. Please request by title and publication number and include a self-addressed business-size envelope. *No postage is required.*

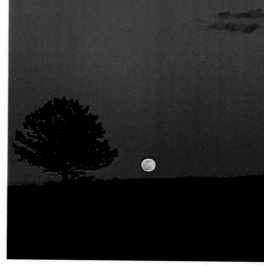

Colorado moonrise over an austere landscape at the edge of the plain

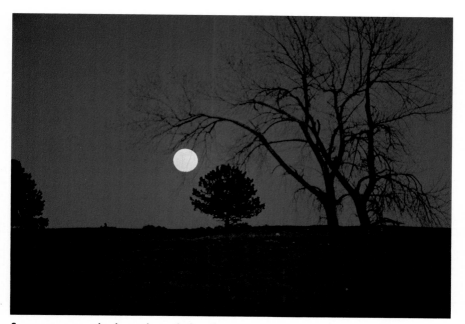

Same moon, same landscape but a darker sky, longer focal length lens, and different shooting position to add another element to the landscape

With a 35 mm lens, the moon is only one element in a skyscape that includes clouds and trees on the horizon.

A 300 mm lens brings the disc of the moon close and clouds scallop its edge to add interest. The pale blue-gray evening sky is a more effective setting than a black night sky would be.

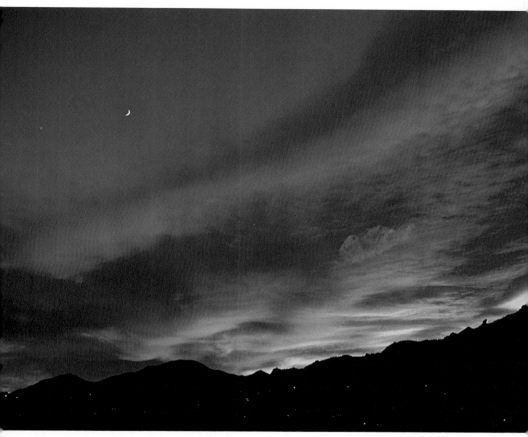

**The brilliant sunset clouds are the main element
of this photograph. But the new moon adds an
unexpected accent.**

A trick that I haven't used much—but that can yield some interesting results, is to shoot a roll of moons, then to run the film through the camera again and shoot some scenery to go with them. This technique was described in detail by Paul D. Yarrows in an article called "Moons in the Refrigerator" in the KODAK Publication *The Here's How Book of Photography*. This book is now out of print; however, copies are probably available at your public library. There are several advantages to this procedure. You can use a telephoto lens to shoot the moon, for example, to make it nice and big; then use a wide-angle lens to drop a panorama of city lights in beneath it. Or instead of waiting for the harvest and hunter's moons, you can catch the full moon at a convenient time and then add a lavender sky, pine trees, or whatever you want. There's a slight bit of deception involved, but it can produce some lovely pictures featuring the moon.

The stars are much dimmer than the moon, so often require exposures of several minutes, even with a clear sky and KODAK EKTACHROME 400 Film. Astronomers secure their telescopes and cameras to a device called an equatorial mount, which moves with the earth's rotation to keep the lens exactly pointed at the subject in the sky during exposures that take minutes or even hours. Without such sophisticated equipment, the stars leave trails on the film, appearing as bright streaks rather than points in the sky. But this effect can be interesting too, especially if you have a mountain peak or other impressive foreground object in the picture.

KODAK EKTACHROME 400 Film and a long exposure can also be used to photograph clouds illuminated only by the glow from city lights below. Again, the effect is not a literal rendition of the subject, but it can be interesting.

A 1-minute exposure with the camera pointed straight up, away from the pollution and the dense lower atmosphere, shows a myriad of stars in the clear sky.

I take star pictures with a 35 mm lens wide open at $f/2$. On a clear Rocky Mountain night, with KODAK EKTACHROME 400 Film, I have used exposures as short as 30 seconds and have obtained a pretty good skyful of stars that appeared as points instead of streaks. However, longer exposures get a lot more stars that are too dim to show up in 30 seconds. When I expose more than 4 minutes the sky tends to lighten so much that the stars begin to fade into the background. But, star photography is affected so heavily by air pollution and other local conditions that you'll have to use up some film experimenting on your own. Once you've adjusted to local conditions, I think you'll be surprised at how many stars your camera can record, as well as the variety of colors that are usually too subtle for the eye to detect.

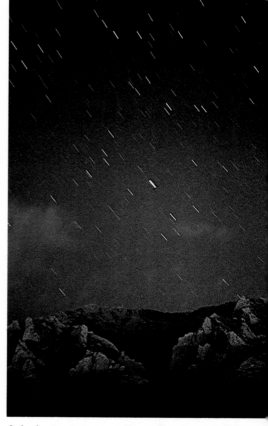

A 4-minute exposure on KODAK EKTACHROME 400 Film turns the stars into meteors showering down on the mountains below.

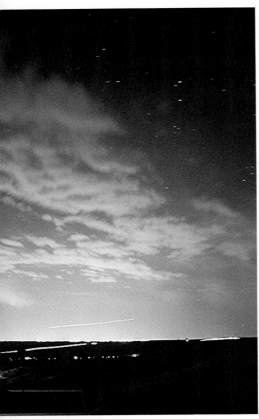

The night sky over Denver was dark to my eye. But a 2-minute exposure on EKTACHROME 400 Film shows it brightly lighted by the glow from the city. The bright streak across the sky above the horizon was made by an airplane and the one on the ground by car headlights on a highway.

TRY IT YOURSELF

I hope that all of my advice about bracketing exposures, shooting a lot of film, and resolutely throwing away your mistakes doesn't sound inappropriately vague for an article in a publication called *Here's How*. These things are necessary to obtain those *special* few pictures that to most of us make it all worthwhile. I think that one of the most fascinating things about taking pictures of the sky is that it can't be done by numbers. All the automatic features that can possibly be added to your camera won't create good sky photographs for you in the great majority of situations—you have to create them yourself. I think the challenge, to apply *my own creative intuition* in photographing clouds, lightning, rainbows, and all the other fascinating things that go on up there, is what keeps me out, year after year, photographing the sky.

Try pointing *your* camera at the sky. Perhaps you'll discover a new world of photographic challenges and fun!